P9-DXJ-752

FLEMISH & DUTCH DRAWINGS

DRAWINGS OF THE MASTERS

FLEMISH & DUTCH DRAWINGS

From the 15th to the 18th Century

Text by Colin T. Eisler

LITTLE, BROWN AND COMPANY BOSTON · TORONTO

COPYRIGHT © 1963 BY SHOREWOOD PUBLISHERS, INC.

ALL RIGHTS RESERVED. NO PART OF THIS BOOK MAY BE REPRODUCED
IN ANY FORM OR BY ANY ELECTRONIC OR MECHANICAL MEANS IN-
CLUDING INFORMATION STORAGE AND RETRIEVAL SYSTEMS WITHOUT
PERMISSION IN WRITING FROM THE PUBLISHER, EXCEPT BY A REVIEWER
WHO MAY QUOTE BRIEF PASSAGES IN A REVIEW.

A

LIBRARY OF CONGRESS CATALOGING IN PUBLICATION DATA

Eisler, Colin T
 Flemish & Dutch drawings: from the 15th to the 18th
century.

 Reprint of the ed. published by Shorewood Publishers,
New York, in series: Drawings of the masters.
 Bibliography: p.
 1. Drawings, Flemish. 2. Drawings, Dutch.
I. Title. II. Series: Drawings of the masters.
NC258.E35 1976 741.9′492 75-25674
ISBN 0-316-22521-5

*Published simultaneously in Canada
by Little, Brown & Company (Canada) Limited*

PRINTED IN THE UNITED STATES OF AMERICA

Contents

Flemish & Dutch Drawings

The eloquent line, whether in the calligraphy of medieval manuscripts, the interlace of early metalwork or the incised ornament of sculpture, has always been the hallmark of Dutch and Flemish art. The lands now known as Holland and Belgium, together with the southwestern section of Germany provided the pioneers of the graphic arts, the inventors of new drawing techniques and almost every aspect of the discovery of print-making and typography as well. Among the earliest special media for drawing is the silverpoint method, in which a silver or other metal stylus is impressed on chemically prepared parchment or paper, producing a particularly delicate and shimmering line.

Rarely intended as independent works of art, the first drawings were often designer's models, plans for future projects, indications of how a finished commission would appear. The earliest sketches are hastily drawn in the margins of medieval manuscripts, or in small highly-finished renderings for enclosure in pattern books which the traveling artist would take with him to show prospective patrons what he could do. In the late middle ages drawings were generally small in size as all the materials needed were costly. In the fifteenth century, as paper-making became widespread and steadily lower in cost, drawings became larger. Artists who had hitherto made their preparatory drawings directly on the surface of the painting itself, started using paper for their preliminary designs.

Typical of the graceful style of the early fifteenth century, emphasizing refinement and delicacy, are the silverpoint drawings of *The Betrayal of Christ* (Plate 1) and of *A Courtly Company* (Plate 2). In each the artist is also a choreographer, placing his elongated, slender figures in dancing attitudes, whether portraying the Passion of Christ or an aristocratic flirtation. The courtiers' somewhat grimacing faces anticipate the realistic trend of art in the northern Netherlands (later known as Holland). The participants in the *Betrayal,* however, already show the more classical style and less broad char-

Figure 1

Jan van EYCK · *Portrait of Cardinal Albergati* · silverpoint on grayish-white prepared paper, 212 x 180 mm.

Dresden, Staatliche Kunstsammlungen

acterization pointing to developments in the later art of Flanders. Both draw-
ings are closely related to the art of manuscript illumination and may have
been prepared in a workshop like the one shown in the scene of a scribe writ-
ing (Plate 3), dating from the late fifteenth century.

Jan van Eyck's magnificent delineation of his Italian patron, Cardinal
Albergati, is perhaps the most important portrait drawing of all time—never
before was there such mastery of the silverpoint technique or such a vivacious
and at the same time, eternal evocation of the sitter (Figure 1). Perhaps drawn
in a single session, it is covered with color notations for the artist's use in pre-
paring the painting now in Vienna. As is the case with many portrait studies,
the artist's initial sketch is a more personal statement than the meticulously
finished oil painting for which it was made.

The same concern for conveying a sense of the play of light and of subtle
gradations can be seen in two beautiful drawings by Rogier van der Weyden,
the *Virgin and Child* (Plate 4) and *St. Mary Magdalene* (Plate 5). These, to-
gether with portrait drawings from the followers of Dirk Bouts (Plate 7) and
Petrus Christus (Plate 6) continue the luminous explorations begun by Eyck-
ian art. In contrast are the drawings in pen and ink of *Mary and St. John*
(Plate 9) and *Men Shoveling Chairs* (Plate 8). Both have a deliberately sculp-
tural quality, as though they were drawn from or toward works in wood or
stone. Less concerned with careful modulation than with directed motion
and emotion, these ink studies have much of the brute force of the later art of
Bosch and Bruegel.

Hugo van der Goes' *The Meeting of Jacob and Rachel* (Plate 11) shared
the new breadth of pictorial reference which was the Renaissance. More elab-
orate than most drawings before the middle of the century, it combined toned
paper with pen, ink and wash, heightened with white—providing references
to color and texture, light and shade, in a study that defines the plastic quali-

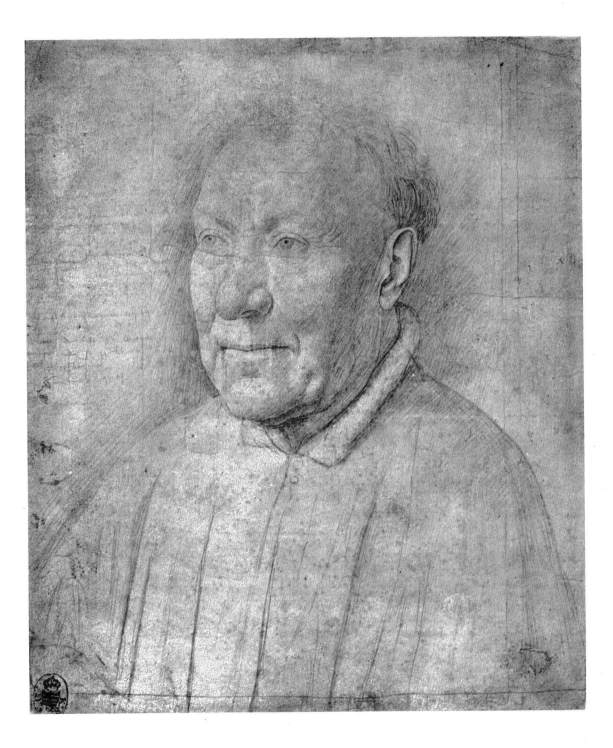

13

ties of the figures as decisively as it does the atmospheric, shimmering landscape. Other drawings from the school of Hugo van der Goes (Plates 12 and 13) —executed in the more sparing technique of pen and ink alone—have an almost *pointillist* quality in their exquisitely rendered hatching—a scintillating network of interwoven strokes, as tremblingly alive as they are descriptive.

Studies in silverpoint from a notebook by an artist working in the studio of Gerard David (Plate 15) mark the close of the great art of the Netherlands in the fifteenth century. The draughtsman has lovingly retraced the triumphs of Eyckian art, isolating heads from the *Adoration of the Mystic Lamb,* the central panel of the great Ghent Altarpiece dedicated in 1432.

Active at the end of the century, the anonymous artist, in dwelling on past achievements in an imitative, rather than a creative manner, sets the note of dependence and emulation which was to result in a flood tide of Italian influence within a very few years, closing the garden of the art of the late middle ages.

The draughtsmanship of Hieronymous Bosch is direct, his grasping, probing lines relentlessly confine their targets—the folly and evil of man—the corruption of godless nature. Impatient with elaborate, illusionistic techniques, and probably intolerant of Renaissance currents, Bosch returns to the roots of northern art to caricature, to a deliberately primitive world. Bosch shows the same concern with physiognomical studies that was one of the driving forces in Leonardo da Vinci's art. Delineating his models with savage objectivity, the artist charts an atlas of evil written in every wrinkle and hair, revealing through the physical decay without, that of the spirit within (Figure 2).

What at first glance appears to be a captivating nature study—Bosch's *The Owl's Nest* (Plate 23)—is actually an illustration of one of the many pessimistic (and untranslatable) Dutch proverbs in which an owl's nest is equated with the evil of life. The dying tree in which the birds of sin roost looms before a

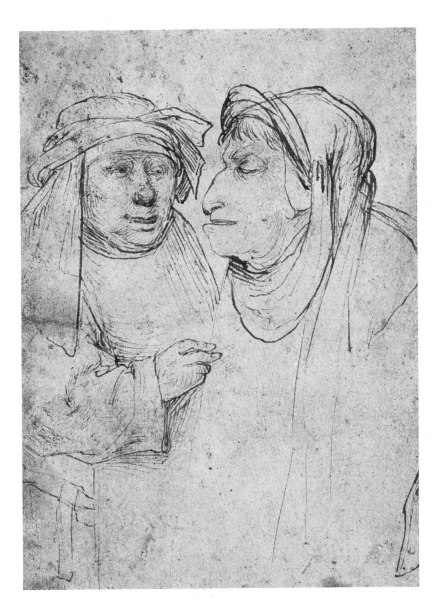

Figure 2

Hieronymous BOSCH
Two Pharisees
pen and ink, 150 x 103 mm.
New York, The Lehman Collection

landscape in which a gibbet rises at the left, while troops mass for battle in its shade. This continuing concern of northern art with nature in the sixteenth century, is in large part due to the view that the world of appearances is in all ways an allegory, a grouping of emblems, an assemblage of symbols bearing witness to the truth beyond.

Early in the sixteenth century, Dutch and Flemish draughtsmen became increasingly aware of the Italian recovery of the art of antiquity, of the new classicism of the High Renaissance below the Alps. They chose pagan subjects —such as Mabuse's *The Judgement of Paris* (Plate 16) or Jan de Beer's *Aristotle and Phyllis* (Plate 19), drawing them with a wiry, spiralling calligraphy as flamboyantly Gothic as the northern architecture of the times. This fusion of native and alien resources produced a new style known as Mannerism. Mabuse observed mercilessly all the accidents of human anatomy with the probing realism of a surgical text while endowing some figures with heads and poses derived from the art of ancient Rome, then newly rediscovered. *Christian II, King of Denmark* (Plate 17) is depicted by Mabuse in a world of conflicting goals—medieval monsters insert themselves in the Corinthian tendrils of the capitals, while classical *putti* seem engaged in mortal combat with the Gothic shields they supposedly support. This disparity of style and ideal is a visual equivalent of the conflict between Protestantism and Catholicism at that time.

No matter what the prevalent style was to be in Dutch and Flemish art the persistence of highly realistic, finished portrait drawing is noticeable throughout the story of Netherlandish draughtsmanship. Even in the most mannered periods of the sixteenth and seventeenth centuries, rigorously representational delineations survive. It is as though artists had two or more styles—that of direct pediction in the case of a portrait, and a far more fanciful and personal mode for other subjects. This can be seen in portrait drawings by Ma-

buse, Goltzius, de Gheyn, Rubens (Plate 32), van Dyck (Plate 45) and Lievens (Plate 59). All these artists could set aside their personal manner in favor of the most directly recognizable image.

Lucas van Leyden was perhaps the most brilliant north Netherlandish artist of the early sixteenth century. A child prodigy, when Lucas was only sixteen years old, his engravings were second only to those of Dürer. Like Mabuse, Lucas was dazzled by the Italian art of the High Renaissance—his animated, nervous pen lines depicting Judith with the *Head of Holofernes* (Plate 21) reflect the style of the Mannerists of Antwerp, the major center of Flemish art, where Lucas worked in 1521. His chalk studies are executed in a freer way, pointing towards the Baroque breadth of vision. The little *David* (Plate 22), shown dwarfed by the sword with which he decapitated Goliath, is similar to chalk studies by Dürer, who exchanged prints with Lucas on the former's journey to the Netherlands.

Many northern artists were great travelers. Journeying in search of patronage, for those who could afford it, the journey also meant the discovery of the art of Italy. Both Mabuse and his north Netherlandish contemporary, Jan van Scorel, worked in Italy for several years. The latter was appointed by Pope Adrian VI (who came from Utrecht) Director of Antiquities in Rome. Although very few drawings by van Scorel survive, they show the Utrecht artist's interest in the Italian landscape and the style of Michelangelo. Van Scorel's muscular figures, seen in the foreground of *Saint Helena Discovering the True Cross* are probably derived from prints made in Rome after the works of Raphael and Michelangelo.

Venetian drawing, painting, and print-making also played an important role in determining the course of Dutch and Flemish draughtsmanship. Itself a halfway-house between North and South, Venice formed a synthesis of the realistic currents of the former with the classical mainstream of the latter.

Landscape studies by Titian and his school, uniting Arcadian vistas with a sense of the specific and the experienced, presented a new approach toward art and nature, soon appropriated by northern artists. Among these was Marten van Heemskerck. First active in Haarlem, he worked on a large scale, using broad, powerful forms. His Roman notebooks of the 1530's provide the most copious documents for the appearance of the city. Recording all the major collections of classical antiquities, van Heemskerck's sketches of Roman palace courtyards jammed with ancient sculpture form a *corpus* of ancient objects known at the time. His forceful, vigorous art never is merely content to record, infusing both ancient and contemporary Rome with a sense of life and purpose which much impressed his stay-at-home fellow artists (Plate 57).

Pieter Bruegel the Elder, despite his Italian travels made about twenty years later than van Heemskerck's, continues Bosch's pursuits, returning to a relentless investigation of his people and their land. Great Alpine landscapes, perhaps drawn on his way home from Italy, have a breadth and monumentality reminiscent of oriental art (Plate 27). His panoramic vision invites the spectator to "read" the drawing as one would an unfolding landscape scroll of the Sung dynasty. Bruegel's cosmic approach to nature was certainly influenced by the art of Dürer and may have been stimulated as well by Leonardo da Vinci's matchless studies. Italian and northern artists were evolving a new nature-writing, creating a novel vocabulary of form, combinations of brush strokes shaping trees, houses, and figures, in which the white of the paper together with the dark of the drawn line interact in an impressionistic interplay of black and white, a symphony of dots and dashes, a new communication of the experience of appearance.

Bruegel's figure studies have a miniature, almost embroidered quality. They are a collection of closely-studied peasant puppets, to be played in his pictorial productions with their casts of thousands (Plate 28). Early drawings

invite inspection with a magnifying glass—those of Bruegel seem observed through a telescope, his peasant subjects scrutinized from a safe distance, for the amusement of wealthy patrons.

Not only concerned with rustic life and landscape, Bruegel designed innumerable prints dealing with proverbs, many of them employing motifs and even whole compositions from the art of Bosch and earlier masters. In these projects for print-making, Bruegel anticipates the engraver's burin and the etcher's needle, which were later to follow along the lines of his brush and pen. Many of the most highly finished drawings of the century were destroyed as soon as they were completed, since the artist drew directly upon the wood engraver's block.

Drawings by the generation after Bruegel tend to follow van Heemskerck's boldly Italianate style, rather than the former's rustic regionalism. Like Bruegel and van Heemskerck, the outstanding draughtsmen of the later sixteenth century were often engaged in designing prints. No longer dependent upon the masters of the High Renaissance, the art of Spranger, Goltzius, and Bloemaert is based on the languid, courtly aesthetic of Italian mannerists, whose art was much in evidence at Fontainebleau. There many Netherlandish painters worked jointly with their southern colleagues under the patronage of François I and his descendants. Spranger's freely-drawn sketches—where the figures appear to splash themselves across the page—are typical of the large number of nude figure studies surviving from the time. Vast quantities of subjects from Ovid and other venerable ancient classical sources provided artists with the excuse to draw innumerable nudes which were eagerly snapped up by such royal patrons as Rudolph II whose court at Prague included a host of Netherlandish artists. The last traces of Gothicism, still apparent earlier in the century, have vanished from the new figure style. Now the artist seems carried away by his brush, letting it move over the paper, giving the

line a sense of autonomy and random discovery almost like that of twentieth-century action painting.

Perhaps the most significant moment in the history of later northern drawings takes place in the period when the capricious, oblique vision of Mannerist art is fused with a vigorous return to the regional landscape tradition. Bloemaert and de Gheyn's rustic scenes are at once deeply imaginative and exploratory—wholly convincing. Reproduced as prints (*e.g.* Figure 5), Bloemaert's sketches comprise the most popular drawing manual of all time, used almost as much in the eighteenth century as they were before. The art of the Rococo would be unimaginable without his earlier landscape and figure studies where whorls of fingerprint-like lines propel themselves across the page in clusters, creating images through the tensions between the white wedges of paper and defining strokes of ink. The probing drawings of his contemporary, de Gheyn, are more closely allied to the intimate art of Rembrandt. The study of a *Woman on her Deathbed* (Plate 60) with its sense of directness moves away from the bravura draughtsmanship of Mannerism toward a use of line less interested in technical virtuosity than in communication. The glamor of "line for line's sake" is gradually replaced by a confrontation of the subject itself. De Gheyn's *Four Heads of a Horse* (Plate 61) explores form from many different angles. Trained as a print-maker, de Gheyn's drawing is rendered in a technique depending upon the expanding and contracting line of the engraver's burin—even his hatching and use of short dot-lines relates to the print-maker's methods.

De Gheyn's teacher, Hendrick Goltzius, is among the most prolific draughtsmen in the history of art—only Rembrandt and Rubens approach him for range of subject and variety of technique. Significantly enough, Goltzius turned to precisely the same Italian artists who were to inspire Rubens—Barocci, the Carracci and the Zuccari. He took over the richly ex-

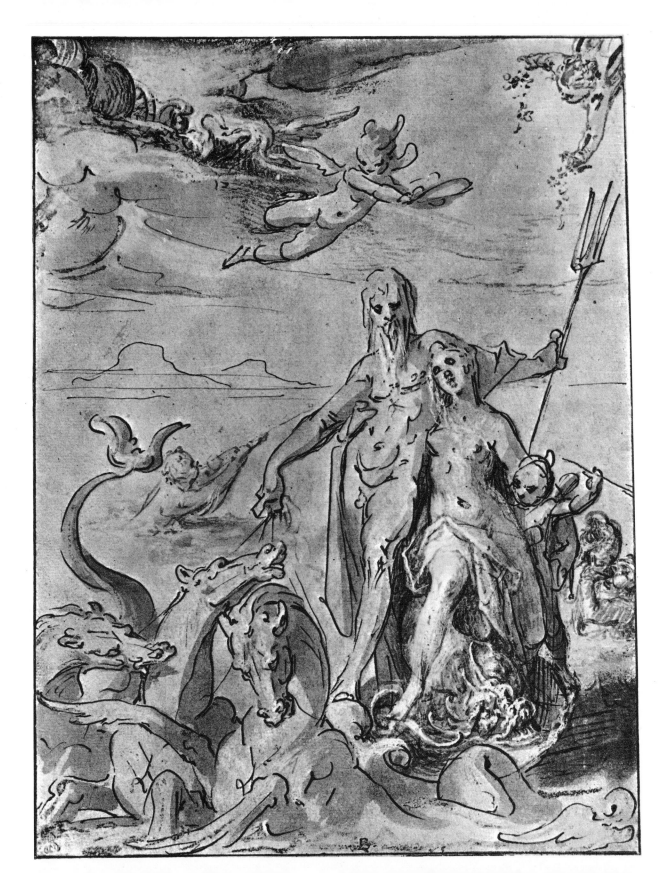

Figure 4

Jan van SCOREL · *The Bridge* · pen and ink, 207 x 154 mm.
London, The British Museum

pressive manner of working in red, black-and-white chalk, which was to become so popular in the eighteenth century when used with Watteau's consummate skill. That the same artist who drew the ravishing woodland sketch brushed on blue paper (Plate 56) with its Claude-like serenity and repose could have also whipped off pen drawings of gods and goddesses shows the many-sidedness and complexity of the art of the late sixteenth century. Goltzius' extraordinary scope—equally at home in the most contrived drawing convention of all time—the bravura calligraphy of his pen drawing—or with the freshest approach to nature as seen in the forest study—is a fitting prelude to Baroque draughtsmanship of the seventeenth century. With the art of Rubens and his followers comes a new union of heroic vision with brilliant graphic techniques, bringing together the separate conquests of Goltzius and his generation.

Working in Rome, Mantua and Genoa, Rubens was more closely associated with Italian patrons and painters than any artist of his time, although many had come to Italy earlier and received most important commissions. Outstanding among these was Paul Brill, a landscape painter from Antwerp who met with great acclaim in Rome and established the permanent colony of expatriate Dutch and Flemish painters known as the *bamboccianti*. Brill's forest scenes (Plate 47), Arcadian vistas, hastily drawn with rapidly moving, almost seismographic strokes, reject Bruegel's topographical approach for an almost expressionistic style, in which each swoop of the pen seems to write out the artist's mental landscape.

Active as diplomat, agent, architect and art dealer, as well as painter, designer of tapestries and books, pageants, prints and sculpture, Rubens' drawings delineate each phase of his almost all-encompassing career. As so many of his projects extended to other media the artist depended upon his brilliantly persuasive draughtsmanship to communicate his ideas to the small

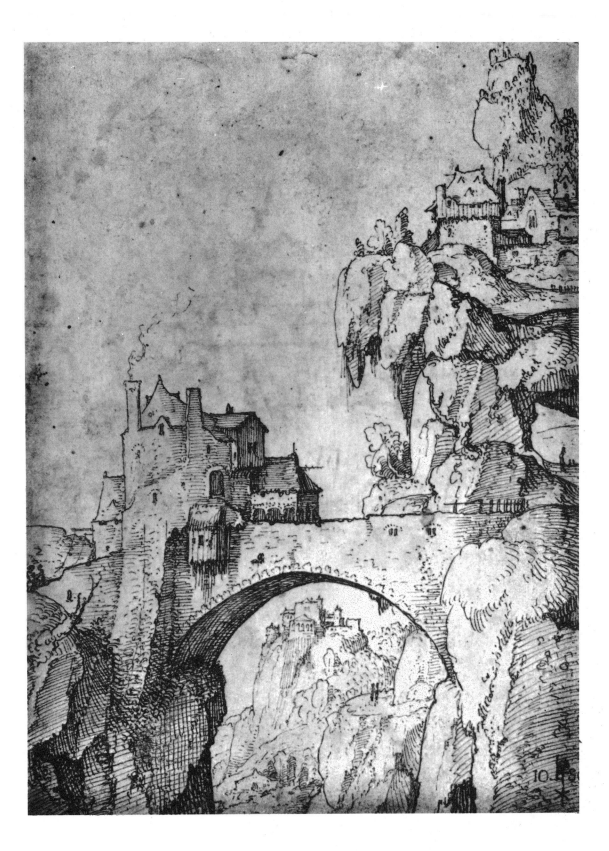

23

army of engravers, weavers, studio assistants, builders and the many others who carried out the colossal number of commissions that seemed to flow in endless profusion from his incredibly productive spirit. Like his Dutch contemporary, Rembrandt, twenty-nine years his junior, Rubens was deeply concerned with the great achievements of the past in Italy and the North. Both made copies and free adaptations after the works of Mantegna and Leonardo da Vinci, as well as the masters of the Venetian and other schools. Both artists were prodigious collectors. While Rembrandt made brilliant drawings based upon the Mogul manuscripts in his possession, Rubens often "completed" the early Italian and northern drawings in his collection— endowed with the audacity and the genius to continue these drawings where the great masters of the past had left them. Although Rembrandt was not involved in making drawings for craftsmen's use, many of his sketches were preliminary studies for his own great series of etchings. He also conducted an unofficial academy where many of the major artists of the later seventeenth century had Rembrandt as their teacher. Very often Rembrandt corrected their drawings, covering over poorly-drawn sections with fresh paper to receive his improvements. The sympathy between student and instructor was so great that it is often difficult to tell their drawings apart.

Both Rembrandt and Rubens worked in a great variety of media. Rarely tiring of experimentation toward new coloristic or textural effects they used red and black chalk, graphite, wax crayons, pen and wash. The bulk of Rembrandt's drawings are executed with pen, brush and brown ink. In this, the most rapid and decisive technique, each stroke represents an unchangeable commitment. Many of his subjects continue those of de Gheyn's intimate world, but the expression has moved away from the incised line of de Gheyn, in favor of a more free and slashing stroke, determined by Rembrandt's supreme mastery of the etcher's needle. Deeply interested in oriental art, using

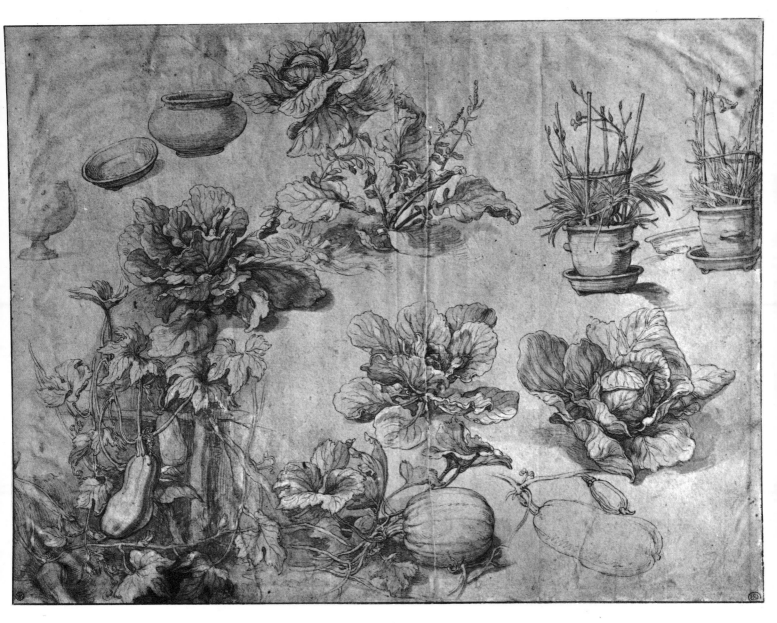

Figure 5

Abraham BLOEMAERT • *Studies of Garden Plants* • pen and ink, 289 x 378 mm. • Paris, Ecole Nationale Supérieure des Beaux-Arts

Japanese and Indian papers for the best of his prints, it is possible that Rembrandt's drawing style may also have been influenced by eastern graphic techniques. Achieving his first great fame as a portraitist, it was this challenging art form that led him to perfect a "speed-writing" drawing mode to record the features of his sitters.

The often overlooked, private world of Rubens shows him to be as direct and spontaneous as Rembrandt. Both shared a common love for their local landscapes. Rubens sketched the lush, verdant land near his Chateau de Steen while Rembrandt made countless reflections of the restrained beauty of canal-crossed lowlands as well as more exotic, romantic drawings like the magnificent *Panorama of London with Old St. Paul's* (Plate 76). Rubens' shimmering woodland studies (Plate 38), his gaily confident approach to the realm of nature as both pleasure garden and birthplace establish the attitude of the great draughtsmen of the Rococo. Watteau, Boucher and Fragonard derived their drawing styles and subjects from those of Rubens, tempering his glamor with some of the rigor and humanity of Rembrandt's art. Some of the greatest Dutch artists left no known drawings—neither Hals, Vermeer or Hercules Seghers seem to have been concerned with draughtsmanship alone. Hals' flying brush may have dashed off the first studies on the waiting canvas, eliminating the need for preliminary drawing. For Vermeer's luminous, prismatic art, with its ineffable union of light, color and mass, the preparatory drawing may have been equally unnecessary. It is only in Saenredam's portraits of architecture (Plate 77) that a Vermeer-like sense of values may be observed in drawings whose purity and silent authority foretell the art of Mondrian in the twentieth century. Only the swaggering cavaliers of Buytewech (Plates 79 and 80) and the vivid landscapes of Esaias van de Velde (Plate 95) present the pioneering figure styles of Hals and the equally innovational rural scenes of Seghers.

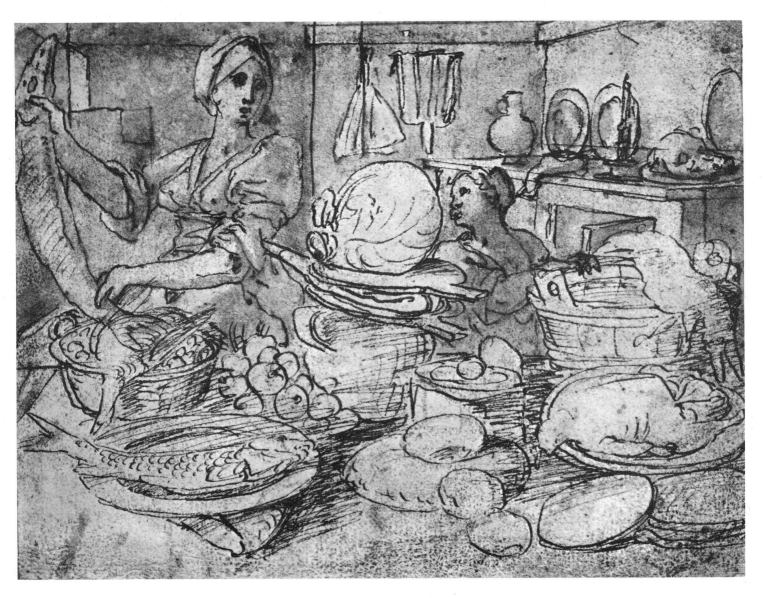

Figure 6

Jodocus van der WINGHE · *Kitchen Scene* · pen and ink, Vienna, Albertina Gallery

Figure 7

Peter Paul RUBENS · *Studies for Apostles* · black chalk on grayish paper, 353 x 258 mm
Cambridge, Mass., Harvard University, Fogg Art Museum

For Utrecht, with its large number of traveling artists who went to Italy and spent much of their lives absorbing the dramatic world of Caravaggio and his circle, Terbrugghen's lusty, freely-drawn *Woman Playing the Penorcon* (Plate 84) and Honthorst's theatrically lit drawings share a concern with a somewhat stagey, larger-than-life approach so characteristic of that center. Working at the same time, Jordaens, while heavily dependent upon his master Rubens, is even more concerned with the blocking out of figures in much the same way that a sculptor "roughs out" form (Plates 51 and 52).

Anthony van Dyck, twenty-two years Rubens' junior when he first worked with that master at the age of eighteen, manifested at that early age his own ideas of draughtsmanship. His drawings are far more abstract than Rubens', devoted to a language of speedy, sinewy elegance, illuminated by dashes of rapidly applied wash and snapping ink lines. Like Rembrandt, van Dyck had no fear of using overtly "ugly" linear passages, if they led to new communications of understanding and experience. There is a breadth and boldness to van Dyck's draughtsmanship which is less readily discernible in his paintings, where the formal requirements of his patrons blind the beholder to the brilliance and audacity with which that formality has been established.

It is within the realm of landscape studies that Dutch and Flemish art unquestionably made its most original contribution. The intimate yet grand appraisal of nature originated in the north and has always been its chief glory. In the seventeenth century with religious painting occupying a very minor role in predominantly Protestant Holland, vast quantities of landscapes were produced and purchased as an investment by many thousands of collectors of modest means. The beautiful Impressionistic sketches by van Ruisdael (Plates 90 and 91), van Goyen (Plate 96), de Koninck (Plates 86 and 87), and Willem van de Velde (Plate 93) were soon admired throughout Europe for their breadth and freedom, their mingled authority and spontaneity. The art of

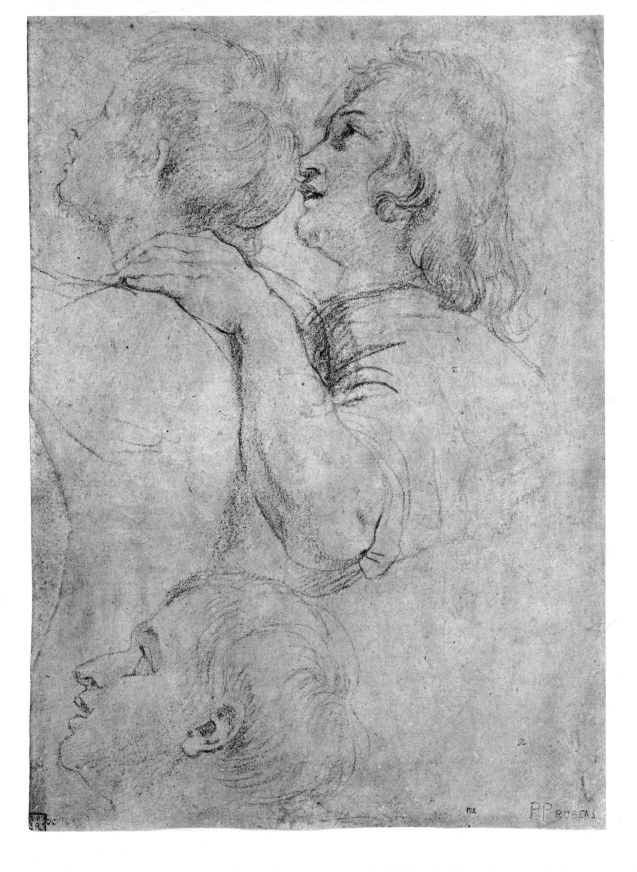

Constable and Turner and that of the Impressionists would have been inconceivable without them.

The aptly-named "Little Masters" of the Dutch and Flemish schools staked out small artistic claims and spent their careers carefully developing a modest range of *genre* subjects of tavern scenes and peasant life. Van Ostade (Plate 81) and Brouwer (Plate 54) with their Daumier-like force and economy of means quickly established the carousing energy of their subjects. Paul Potter's drawing of a bull (Plate 94), using black pencil and wax so freely and lightly that it suggests a study in charcoal and pastel, points toward Fragonard's animal studies in the eighteenth century. Jan van Huysum, whose career extended through the first half of that century has the grandeur and the gaiety of the best art of the Rococo. Arranged with calculated informality, his sprays of flowers swirl around their *putti*-embossed container in a series of carefully-timed floral fireworks (Plate 98). Dutch and Flemish artists were innovators in flower paintings, first included in religious subjects as symbols of the vanity of all earthly things. It seems fitting to conclude this survey of earlier Dutch and Flemish draughtsmanship with van Huysum's flower piece, as drawings like this have proved a surprisingly enduring and hardy witness to the perpetual fertility and abundance of the artistic imagination, in that most perishable and transitory of all media—the drawing.

COLIN T. EISLER
The Institute of Fine Arts
New York University

Plates

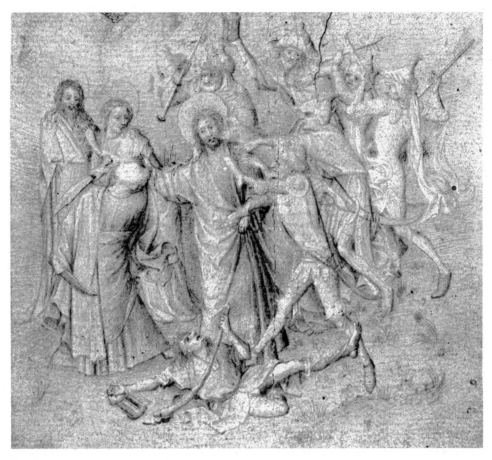

Plate 1

NETHERLANDISH, ca. 1420 · *The Betrayal of Christ* · silverpoint on grayish-green prepared paper, heightened with white, 117 x 132 mm.
London, The British Museum

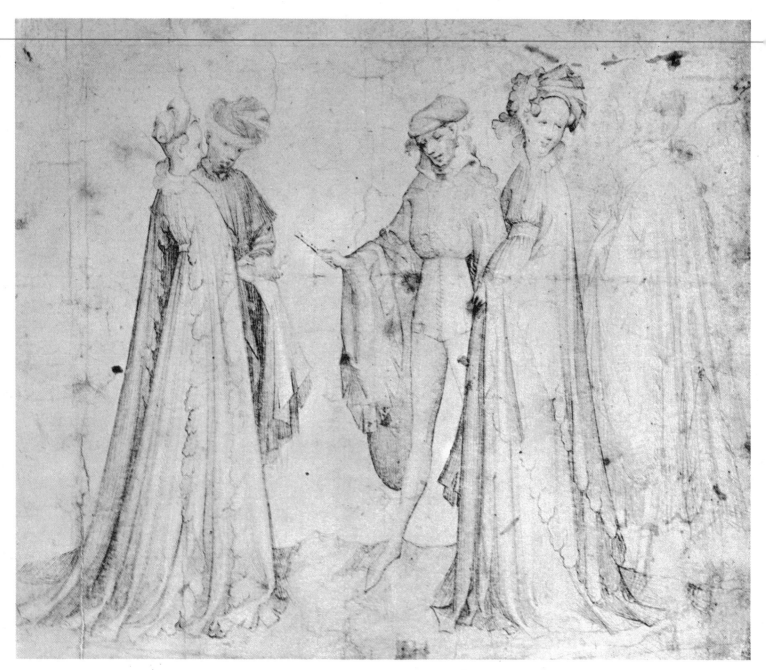

Plate 2

NETHERLANDISH (Attributed to) early 15th century • *A Courtly Company* • silverpoint, 175 x 202 mm.
Uppsala, Royal University Library

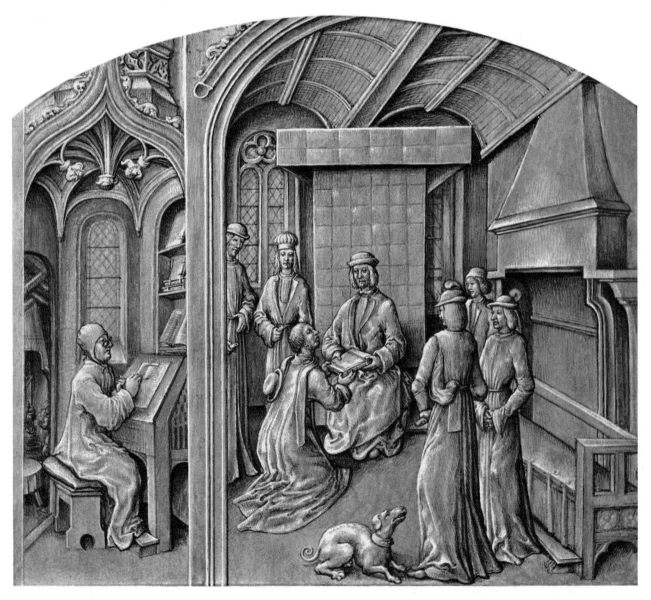

Plate 3

NETHERLANDISH, late 15th century · *Scribe Writing, the Author Presenting His Book* · brush and blue water color on gray prepared paper, heightened with white and gold, 164 x 185 mm., Washington, D. C., National Gallery, Rosenwald Collection

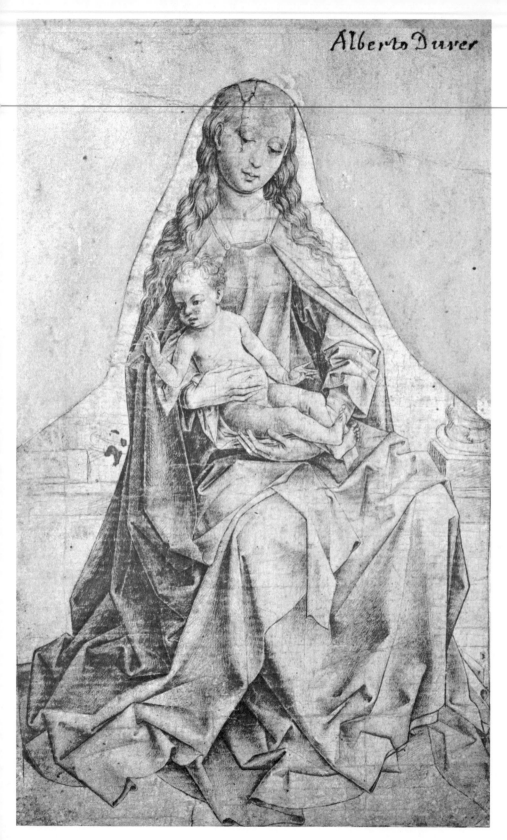

Plate 4
Rogier van der WEYDEN
Virgin and Child
silverpoint on white prepared paper
195 x 127 mm.
Rotterdam, Museum Boymans-van Beuningen

Plate 5
Rogier van der WEYDEN
St. Mary Magdalene
silverpoint on ivory prepared paper
176 x 130 mm.
London, The British Museum

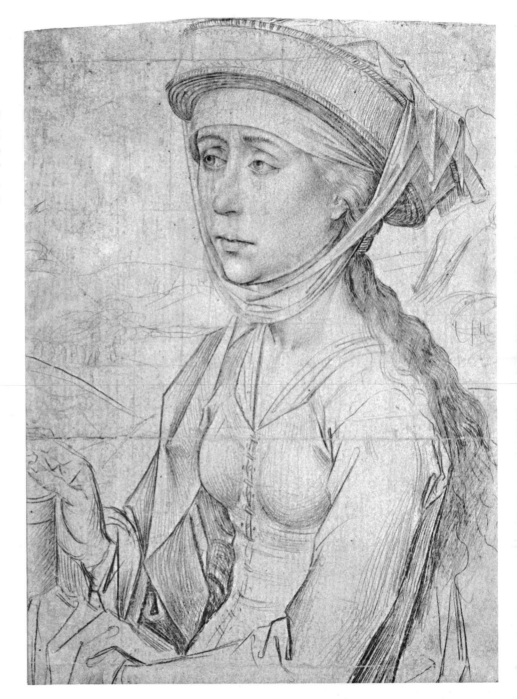

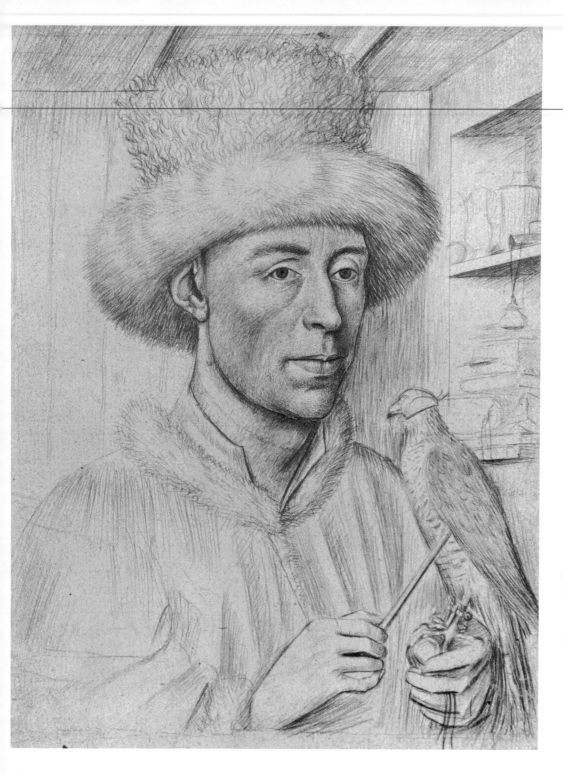

Plate 6
Petrus CHRISTUS (after)
Portrait of a Man with a Falcon
silverpoint on ivory prepared paper
189 x 143 mm.
Frankfort-on-Main, Staedel
Art Institute

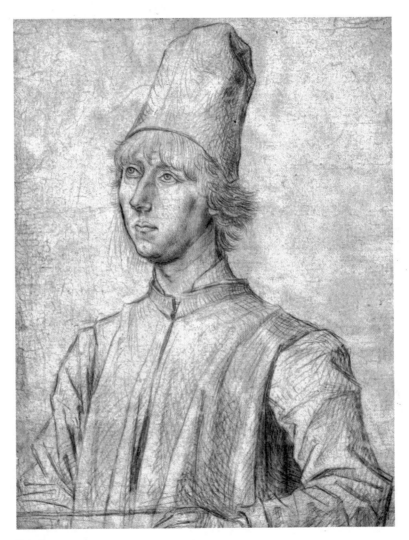

Plate 7

Dirk BOUTS · *Portrait of a Young Man* · silverpoint on gray-white prepared
paper, 130 x 106 mm. · Northampton, Mass., Smith College Museum

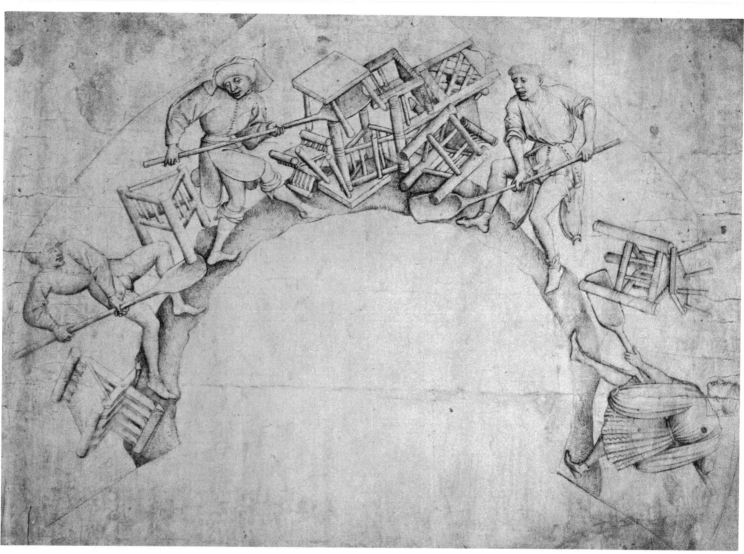

Plate 8

NETHERLANDISH, ca. 1450 • *Men Shoveling Chairs* • pen and brown ink over black chalk, 298 x 425 mm.
New York, The Lehman Collection

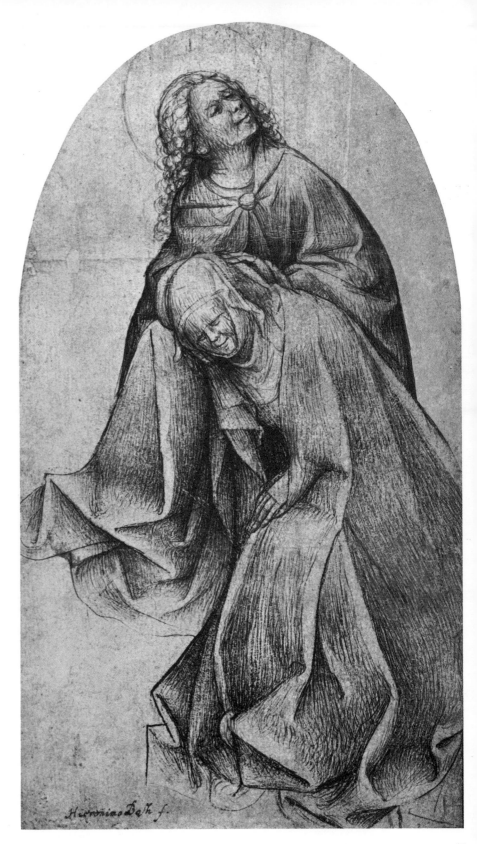

Plate 9
NETHERLANDISH, ca. 1420-1450
Mary and St. John
point of the brush or pen and brown ink,
arched at the top, 302 x 172 mm.
Dresden, Staatliche Kunstsammlungen

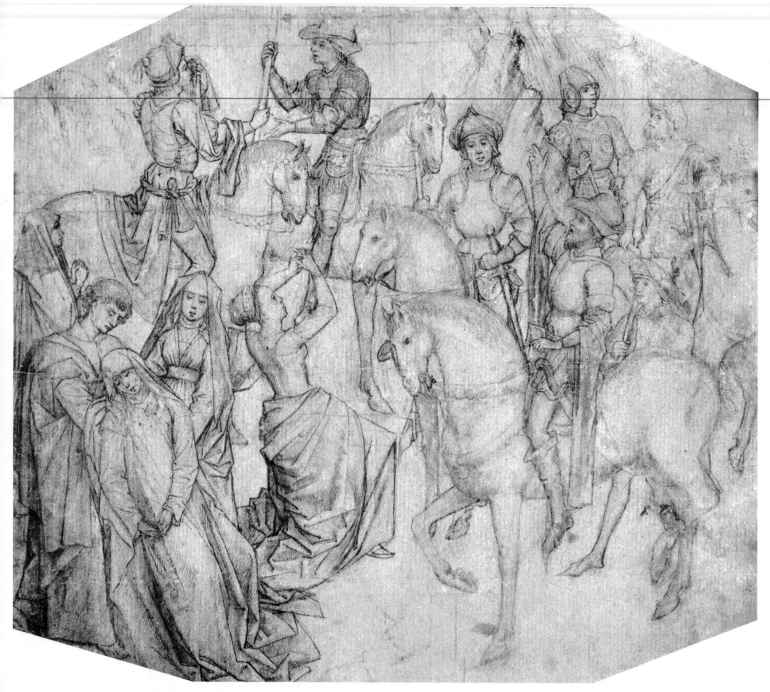

Plate 10

Hans MEMLING (Attributed to) · *Group for a Calvary* · *pen and brown ink over black chalk, 257 x 289 mm.*
London, The British Museum

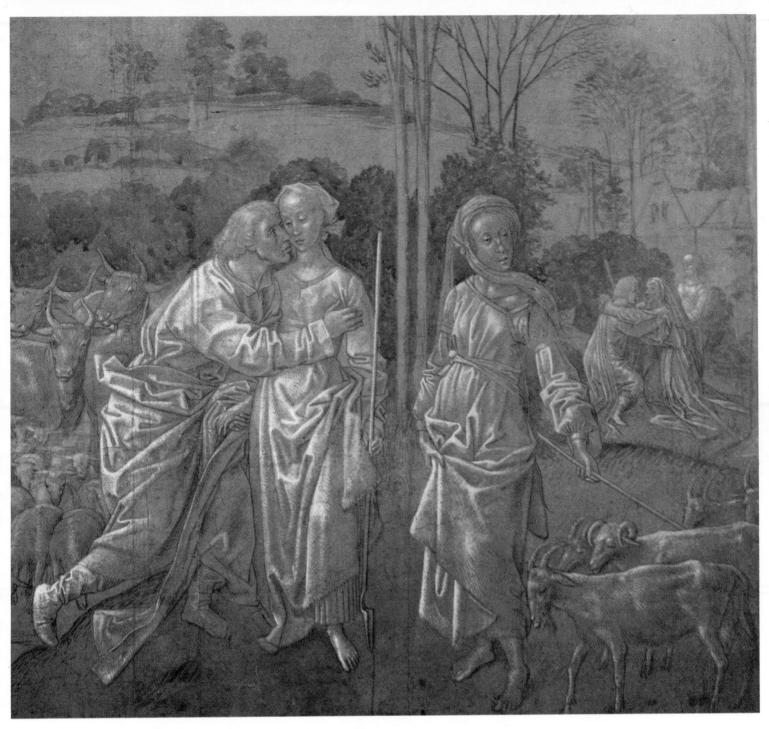

Plate 11

Hugo van der GOES · *The Meeting of Jacob and Rachel (Detail)* · pen and brown ink, brown wash, heightened with white,
on dark-gray prepared paper, 340 x 570 mm.
Oxford, Christ Church
Reproduced by permission of The Governing Body of Christ Church, Oxford

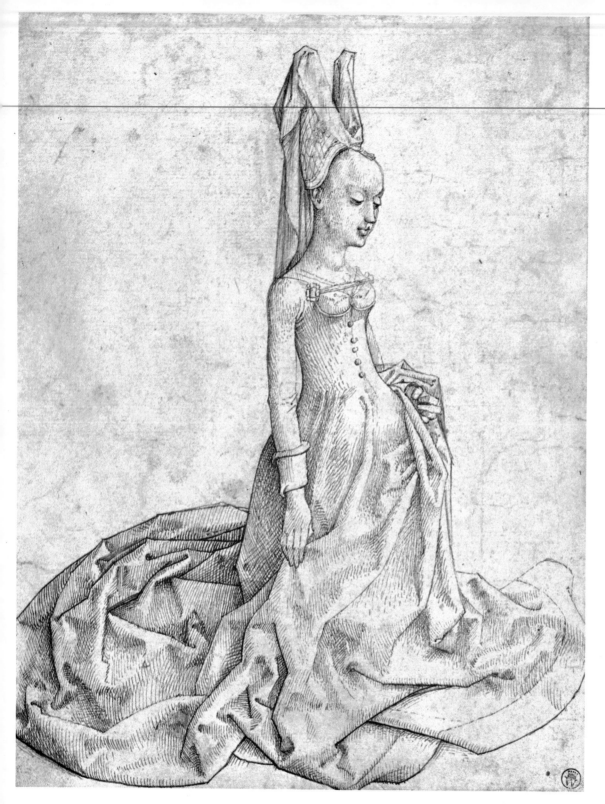

Plate 13

School of Hugo van der GOES
St. George and the Dragon
pen, ink, 165 x 203 mm.
Washington, D. C.
National Gallery of Art
Rosenwald Collection

Plate 12

School of Hugo van der GOES
Kneeling Woman
pen and brown ink
242 x 186 mm.
New York
Pierpont Morgan Library

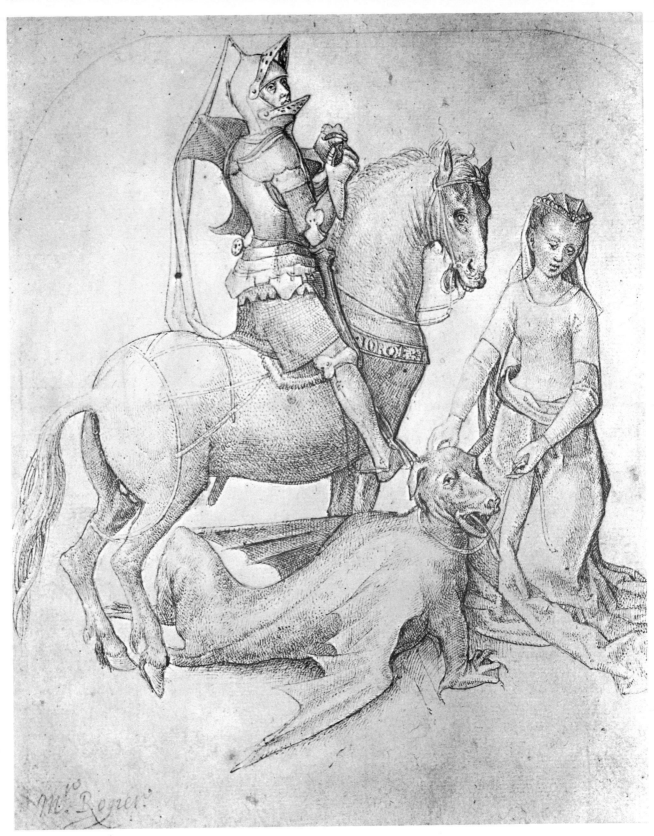

45

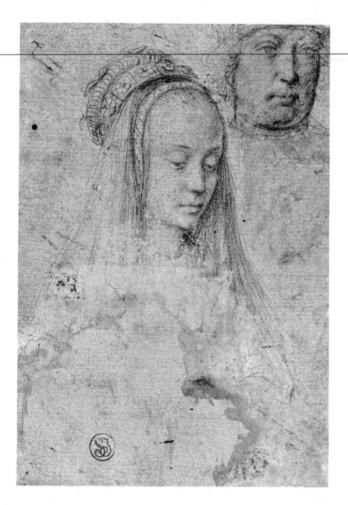

Plate 15

Gerard DAVID
Studies of a Young Woman's and of a Man's Head
silverpoint, 128 x 93 mm.
Frankfort-on-Main, Staedel Art Institute

Plate 14

Gerard DAVID
Studies of Four Heads
silverpoint on ivory prepared paper
70 x 65 mm.
Ottawa, National Gallery of Canada

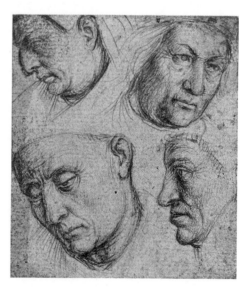

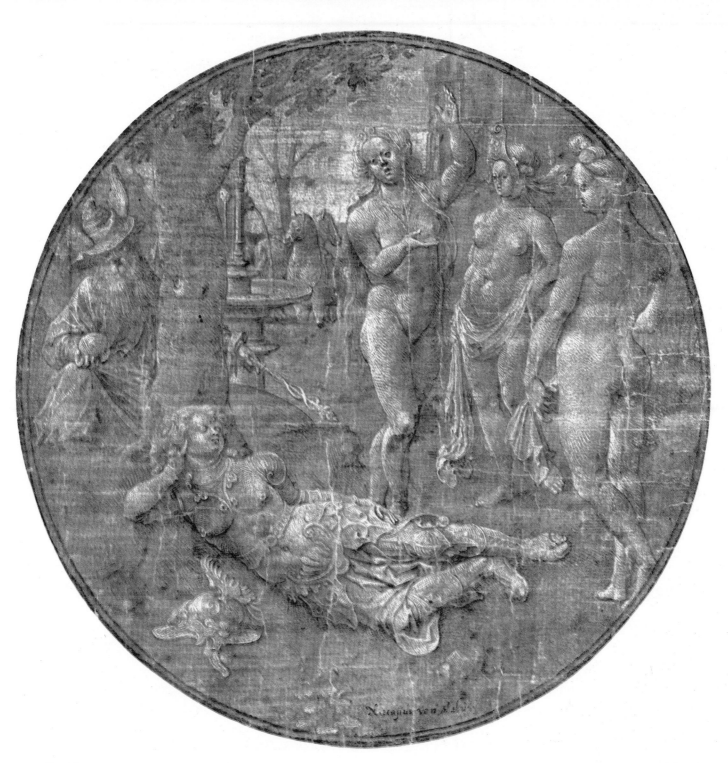

Plate 16

Jan Gossaert (called MABUSE) · *The Judgement of Paris* · brush and gray ink, heightened with white, on bluish-gray paper, tondo —235 mm. diam. · Edinburgh, National Gallery of Scotland

47

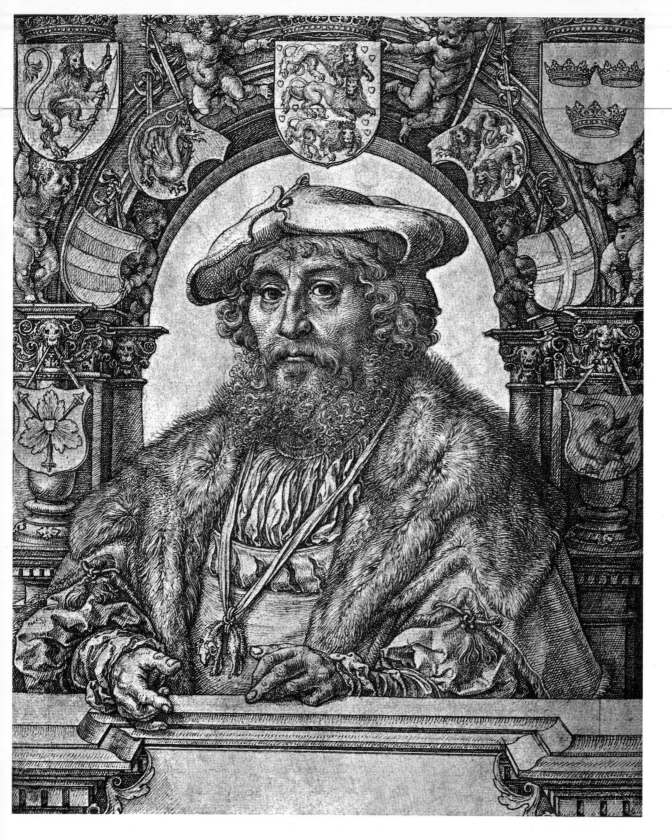

48

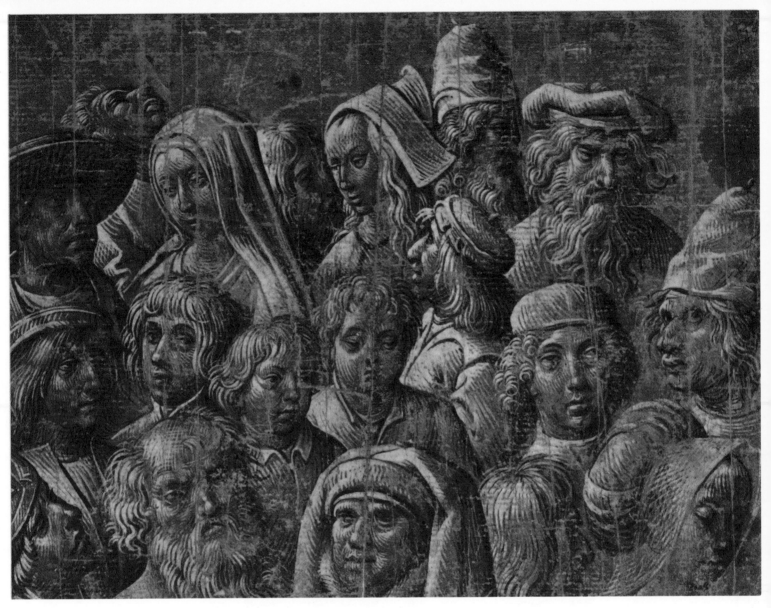

Plate 18

Cornelis ENGELBRECHTSEN · *Heads of Men, Women and Children* · brush with gray and white color on gray prepared paper, 173 x 254 mm. · Amsterdam, Rijksmuseum

Plate 17

Jan Gossaert (called MABUSE) · *Christian II, King of Denmark* · pen and brown ink of two shades, 267 x 215 mm. · Paris, Frits Lugt

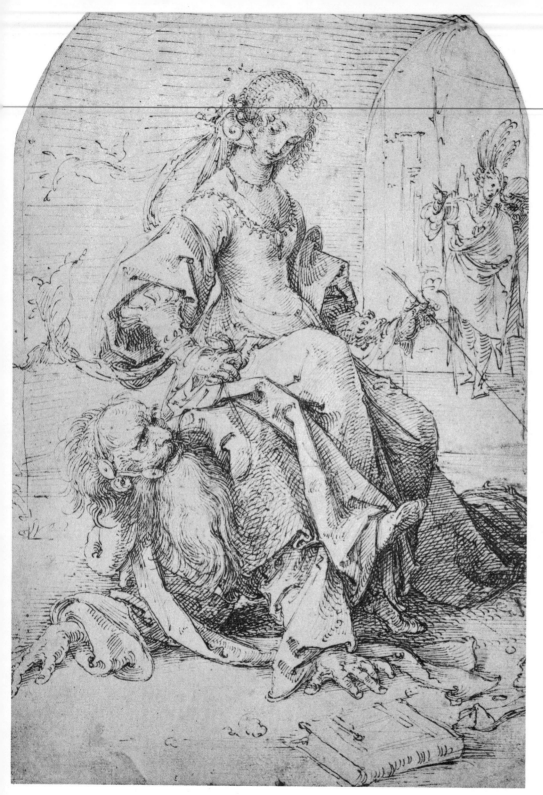

Plate 20

Lucas van LEYDEN
An Old Man Drawing
black chalk, 272 x 272 mm.
London, The British Museum

Plate 19

Jan de BEER
Aristotle and Phyllis
pen and brown ink, 274 x 192 mm.
London, The British Museum

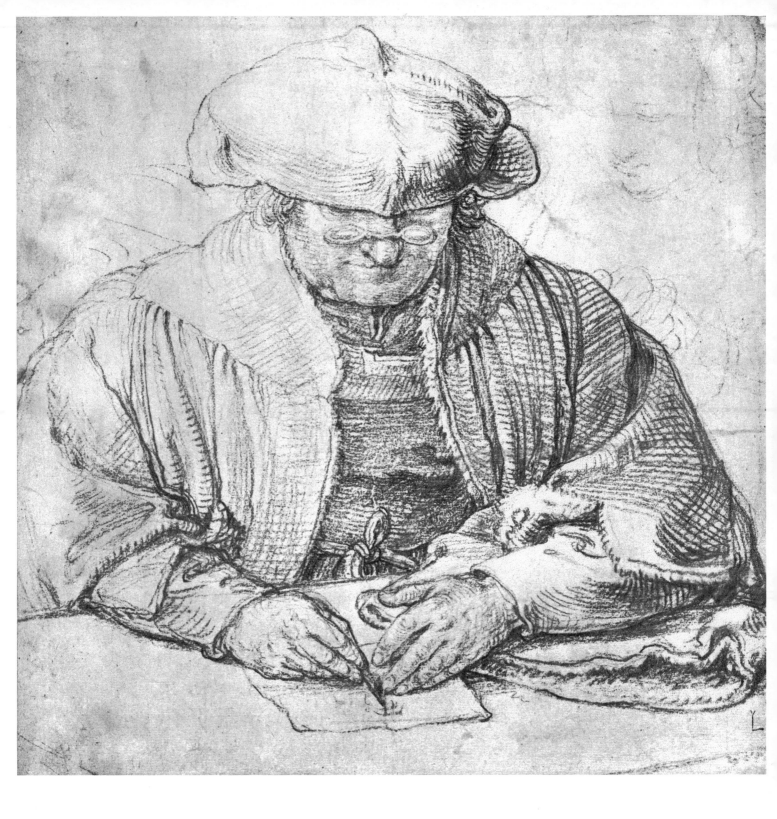

51

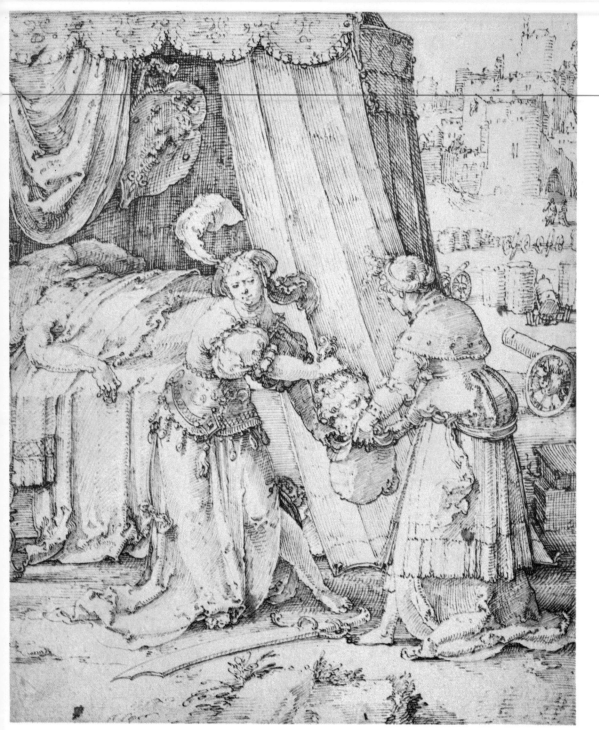

Plate 21

Lucas van LEYDEN · *Judith with the Head of Holofernes* · pen and brown ink, 248 x 205 mm.
London, The British Museum

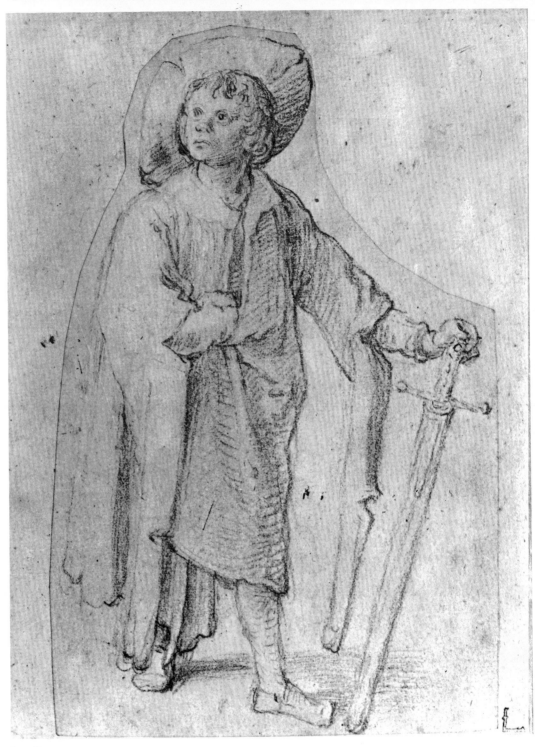

Plate 22

Lucas van LEYDEN · *Study for David Victorious over Goliath* · black chalk on white paper, 240 x 154 mm.
Amsterdam, Rijksmuseum

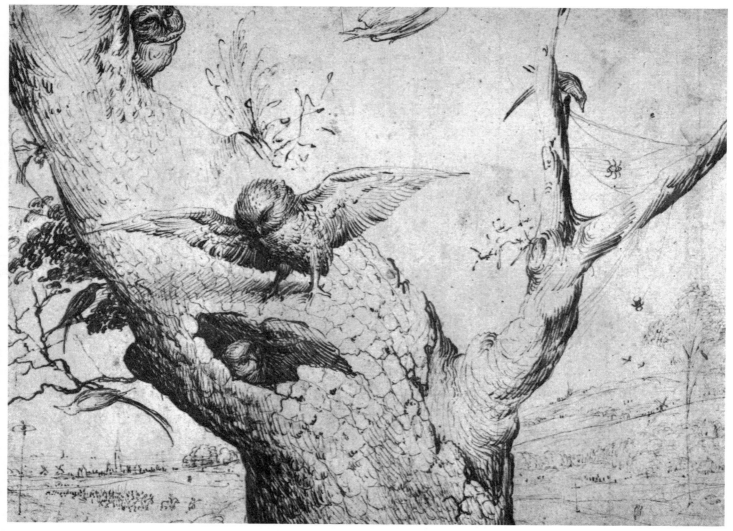

Plate 23

Hieronymous BOSCH · *The Owl's Nest* · pen and brown ink, 140 x 196 mm. · Rotterdam, Museum Boymans-van Beuningen

Plate 24

Hieronymous BOSCH · *Tree-Man in a Landscape* · pen and brown ink, 277 x 211 mm. · Vienna, Albertina Gallery

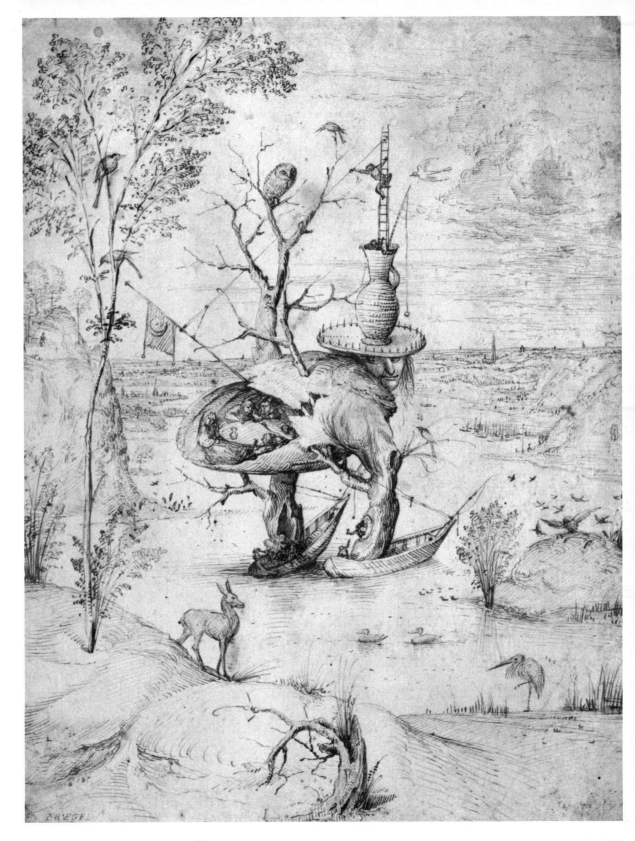

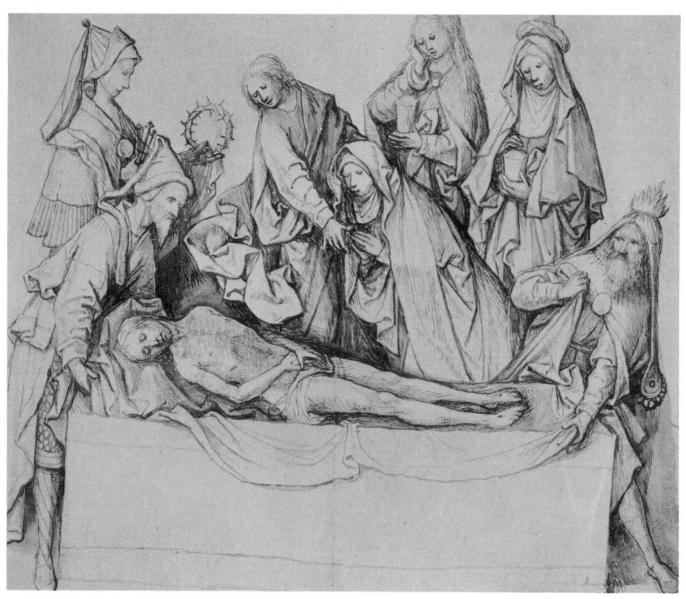

Plate 25

Hieronymous BOSCH · *The Entombment* · brush and gray ink over black chalk, 250 x 350 mm. · London, The British Museum

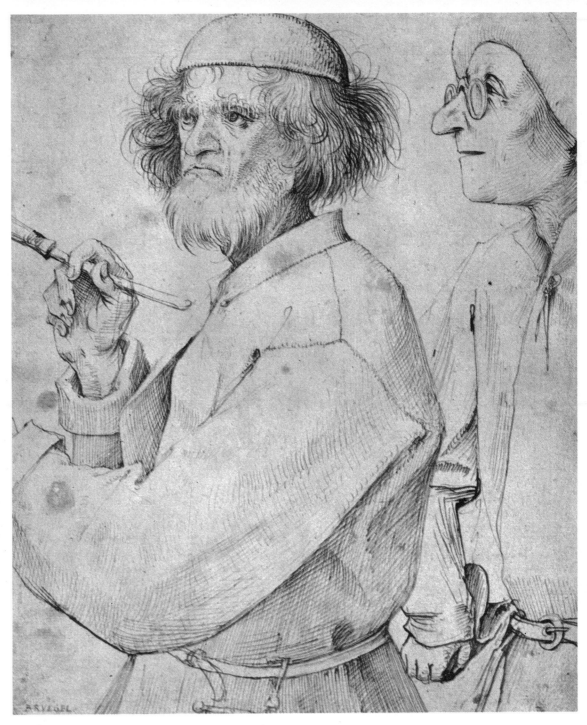

Plate 26

Pieter BRUEGEL the Elder · *The Painter and the Connoisseur* · pen and bistre, 255 x 215 mm.
Vienna, Albertina Gallery

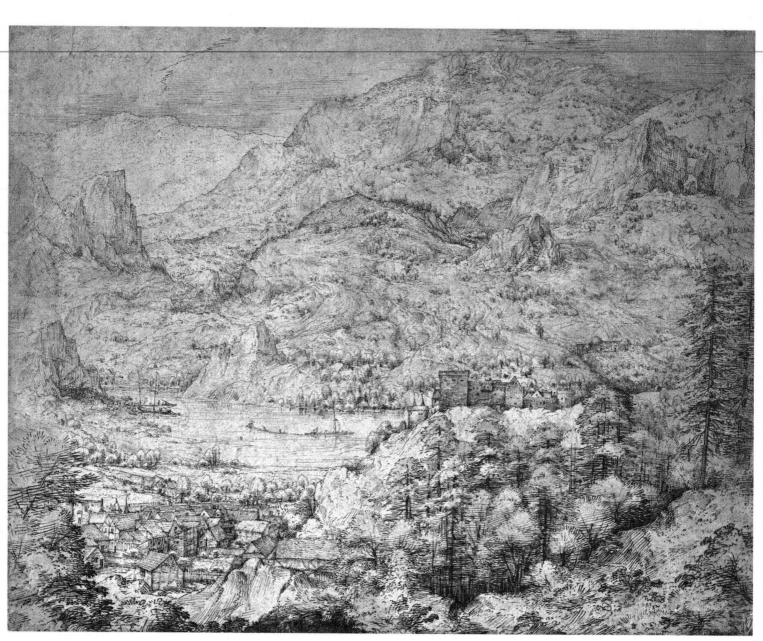

Plate 27

Pieter BRUEGEL the Elder • *Alpine Landscape with a River, Village and Castle* • pen and brown ink, and brown wash, 357 x 444 mm.
New York, Pierpont Morgan Library

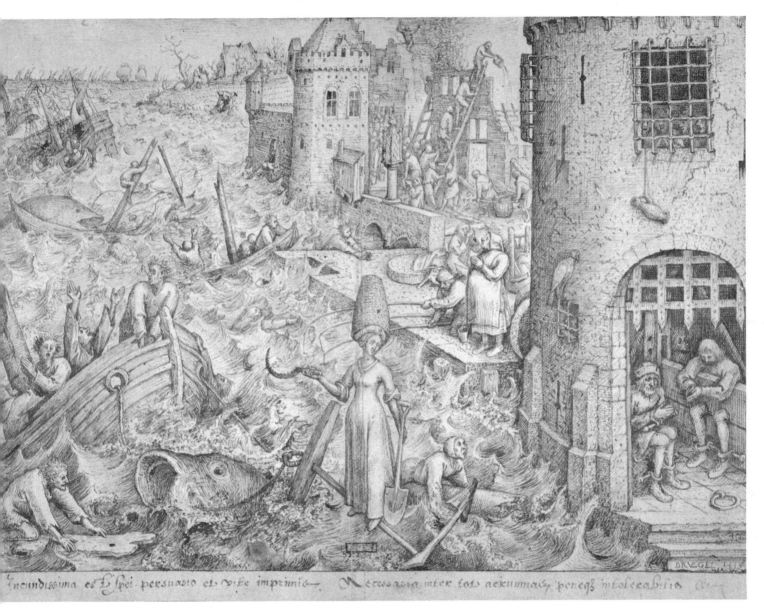

Iocundissima est Spei persuasio et vitae imprimis... Necessaria inter tot aerumnas peneq́ intolerabilis...

Plate 28

Pieter BRUEGEL the Elder · *Spes (Hope)* · pen and brown ink, 224 x 285 mm. · Berlin, Kupferstichkabinett

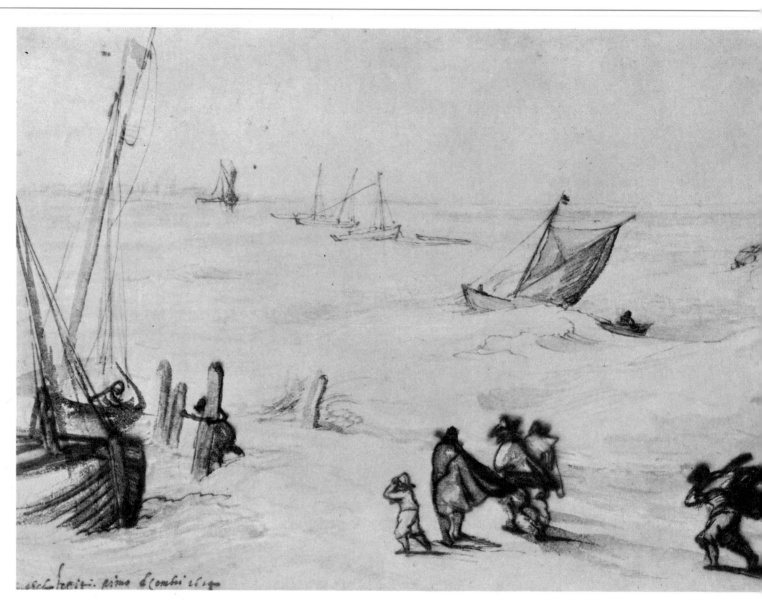

Plate 29

Jan BRUEGHEL the Elder · *Stormy Sea* · pen and brush with brown and blue ink, 195 x 232 mm. · Berlin, Kupferstichkabinett

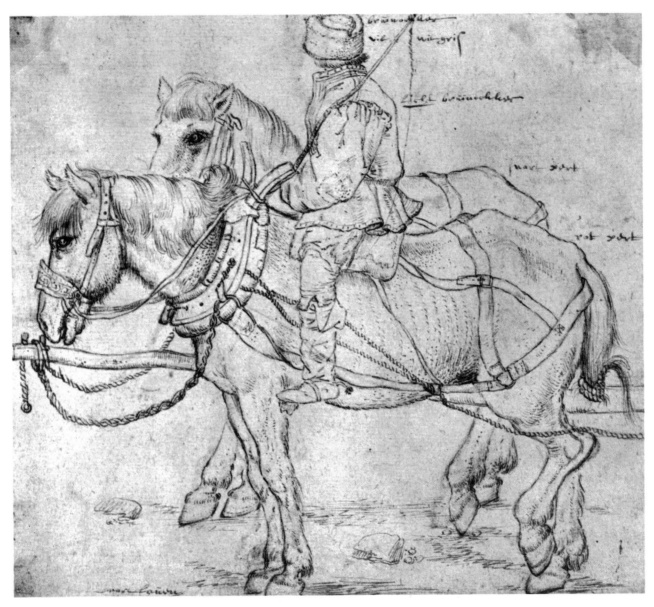

Plate 30

Pieter BRUEGEL the Elder • *Rider and Two Horses* • Pen and bistre over black chalk, 164 x 184 mm. • Vienna, Albertina Gallery

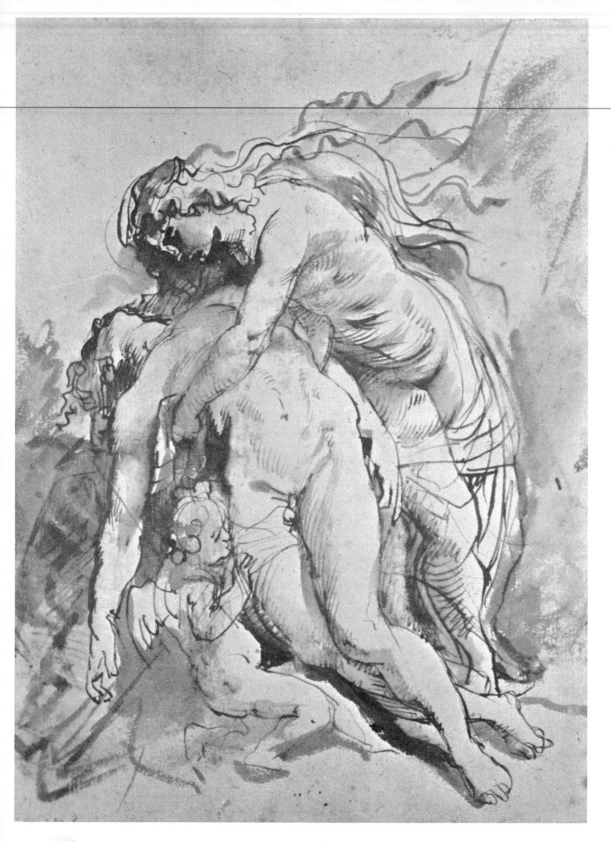

Plate 31

Peter Paul RUBENS
The Death of Adonis
pen and brown wash
217 x 153 mm.
London, The British Museum

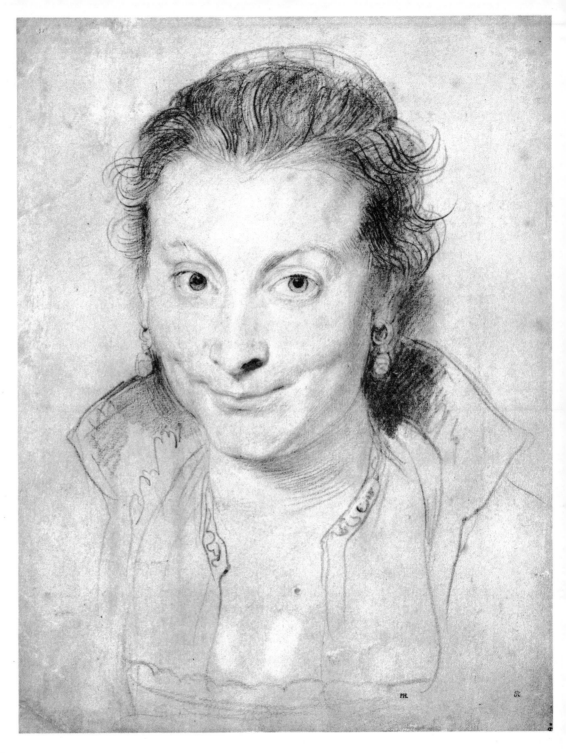

Plate 32
Peter Paul RUBENS
Portrait of Isabella Brandt
black, red and white chalk
381 x 292 mm.
London, The British Museum

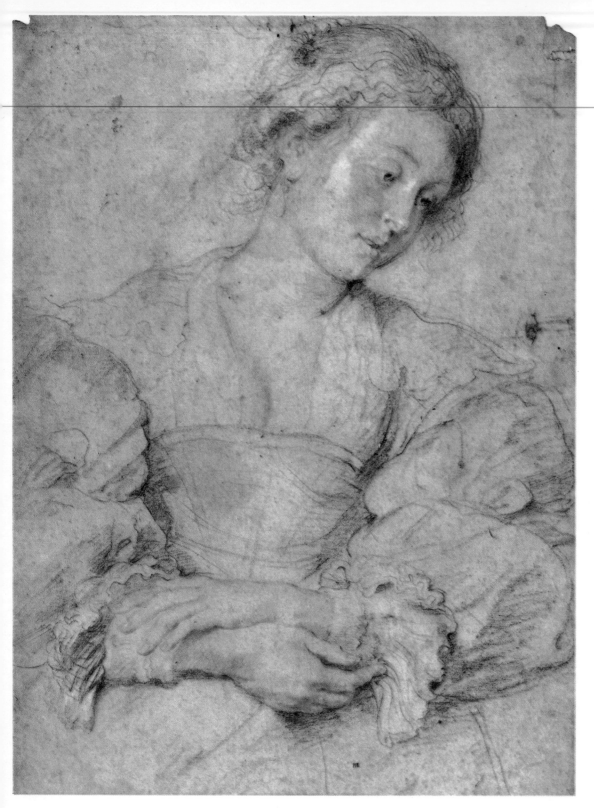

Plate 33

Peter Paul RUBENS
*Young Woman with
Crossed Hands*
black and red chalk,
heightened with white
470 x 358 mm.
Rotterdam, Museum
Boymans-van Beuningen

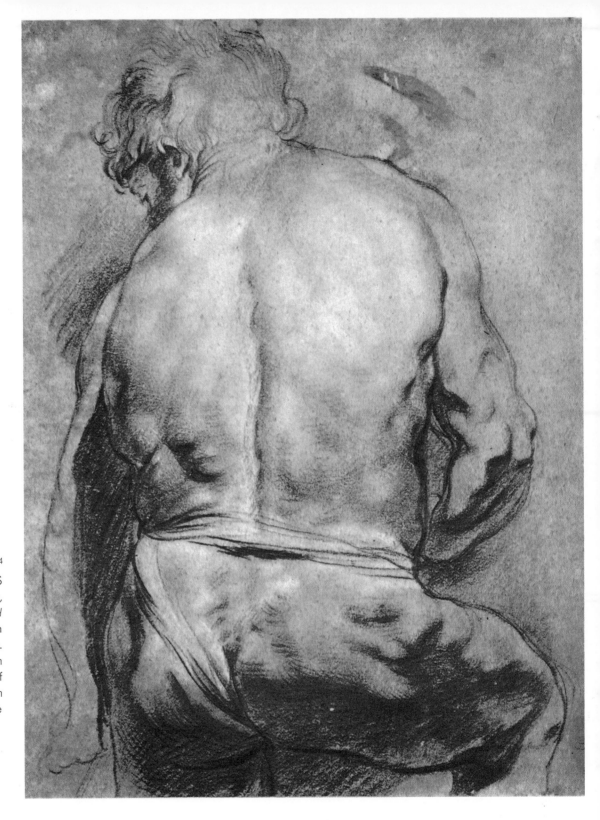

Plate 34
Peter Paul RUBENS
*Study of a Male Figure,
Seen from Behind*
charcoal, heightened with
white, 375 x 285 mm.
Cambridge, Fitzwilliam Museum
Reproduced by permission of
The Syndics of the Fitzwilliam
Museum, Cambridge

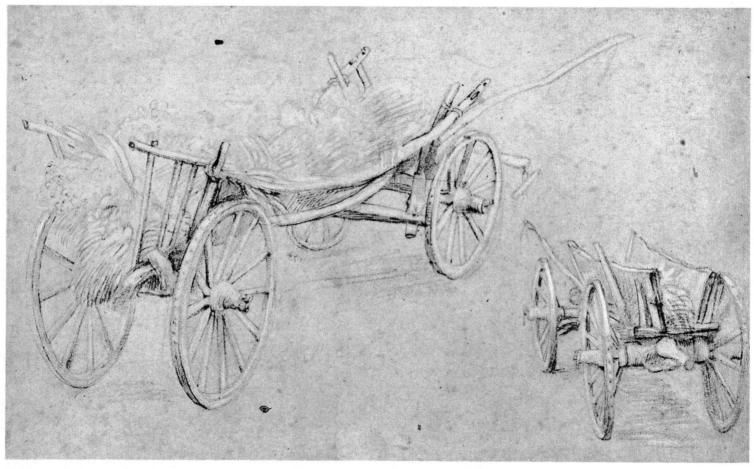

Plate 35

Peter Paul RUBENS · *Two Farm Wagons* · black chalk, heightened with white, and brown pen, colored chalks, 224 x 375 mm.
Berlin, Kupferstichkabinett

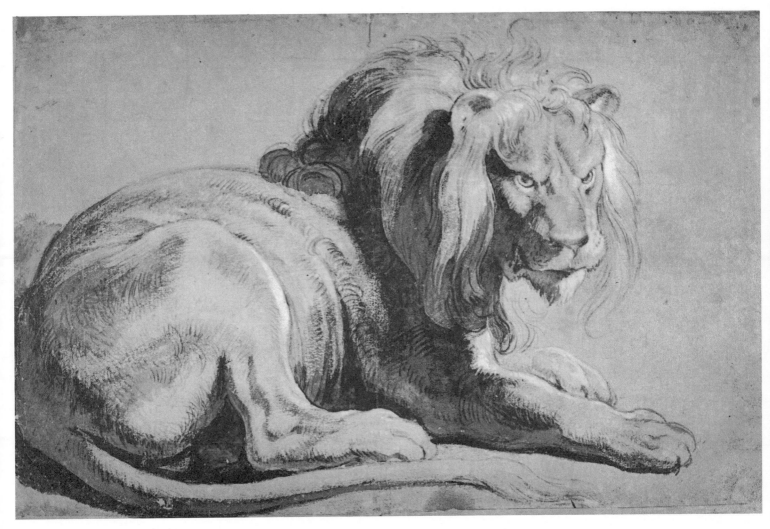

Plate 36

Peter Paul RUBENS · *Study of a Lion* · black chalk, brush and brown ink heightened with white, 283 x 429 mm.
London, The British Museum

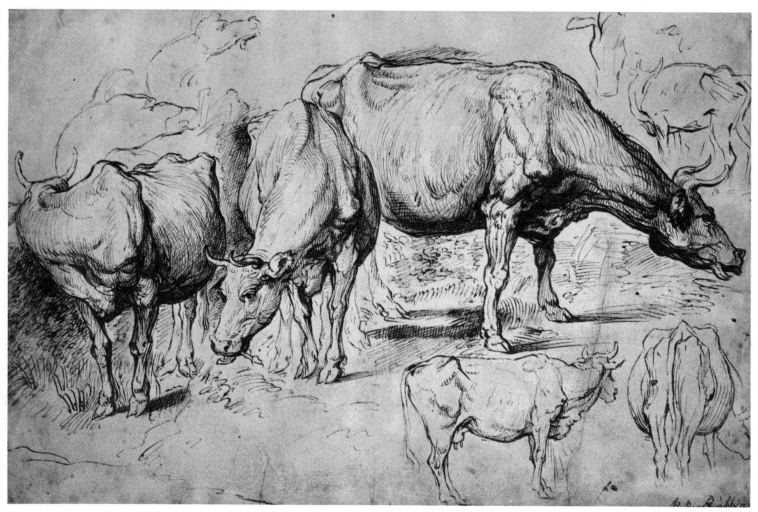

Plate 37

Peter Paul RUBENS · *Study of Cows* · pen and brush and brown ink, 340 x 522 mm. · London, The British Museum

Plate 38

Peter Paul RUBENS · *Tree with Brambles* · pen and brown ink over black chalk with a few touches in red chalk and in blue
352 x 298 mm. · Chatsworth, Devonshire Collection. Reproduced by permission of the Trustees of the Chatsworth Settlement

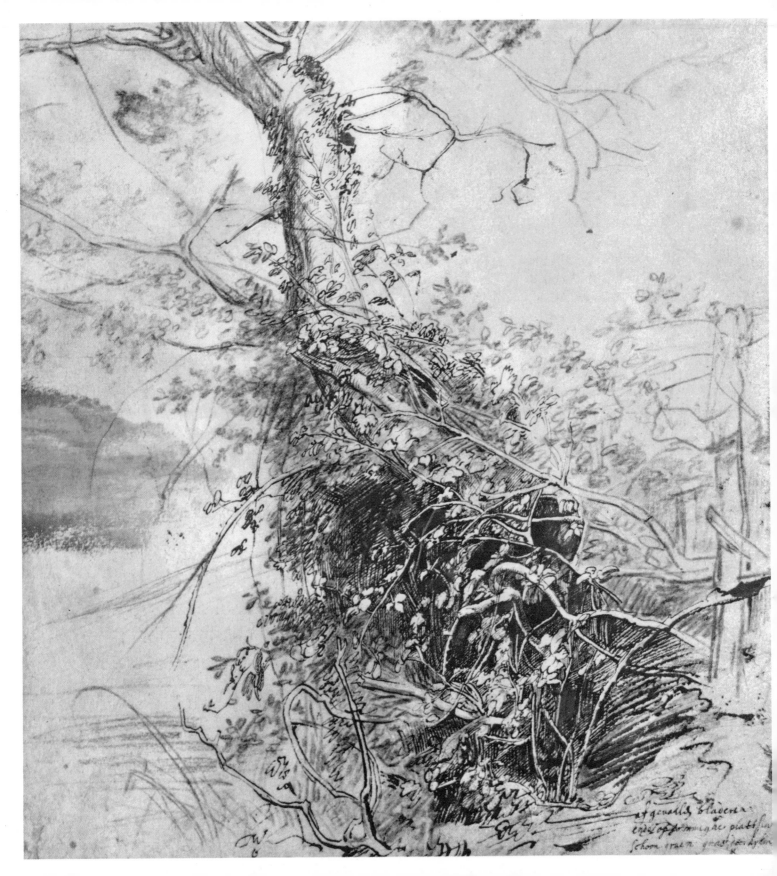

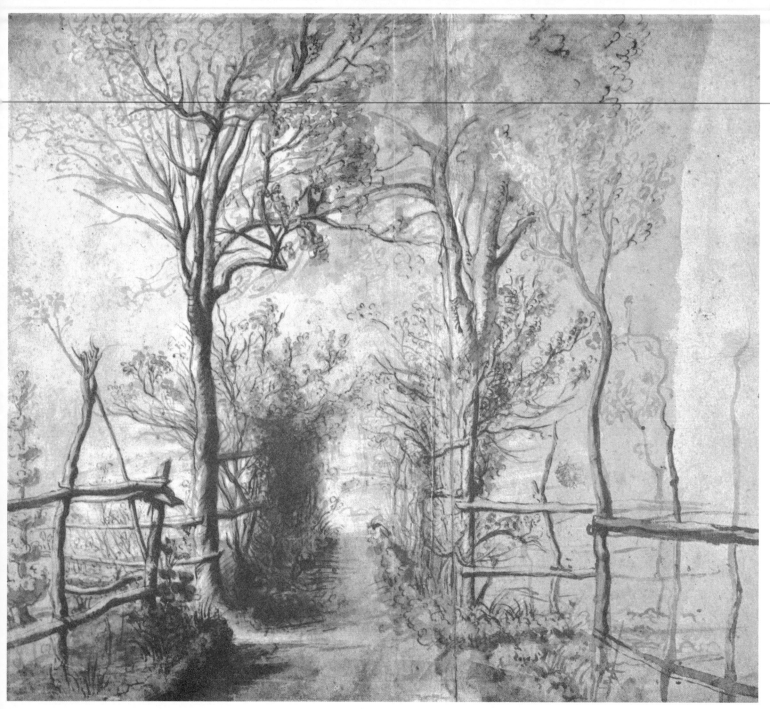

Plate 39.

Peter Paul RUBENS · *A Country Lane* · bistre, pen, wash and pencil, 313 x 403 mm. · Cambridge, Fitzwilliam Museum
Reproduced by permission of The Syndics of the Fitzwilliam Museum, Cambridge

Plate 40

Peter Paul RUBENS · *Three Caryatids, after Primaticcio* · red chalk, largely worked over in red water color with a fine brush heightened with white body-color, turned yellow, 269 x 253 mm. Rotterdam, Museum Boymans-van Beuningen

70

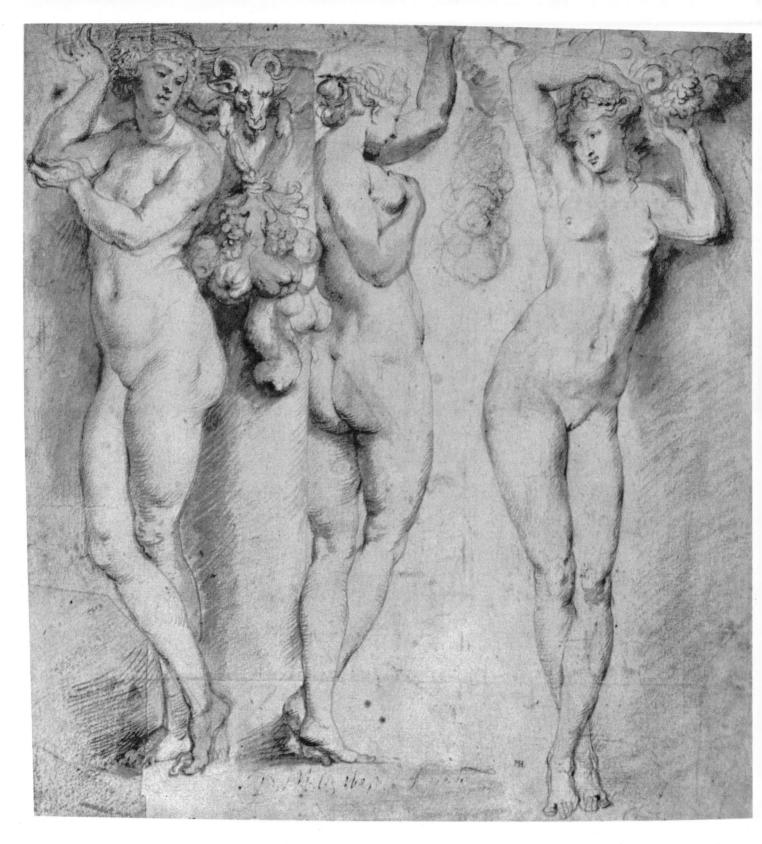

71

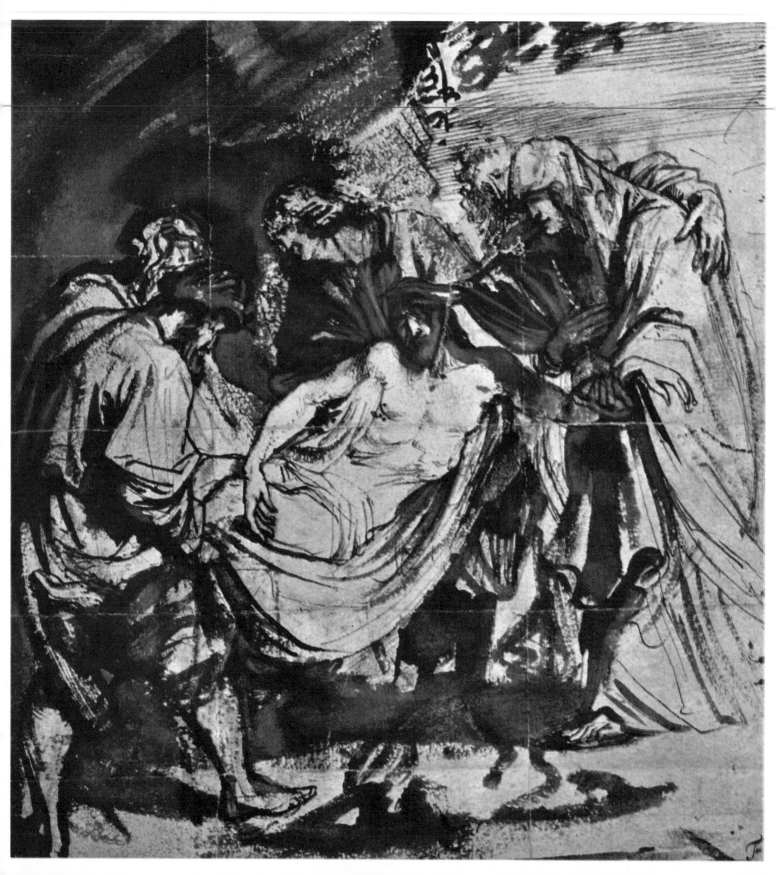

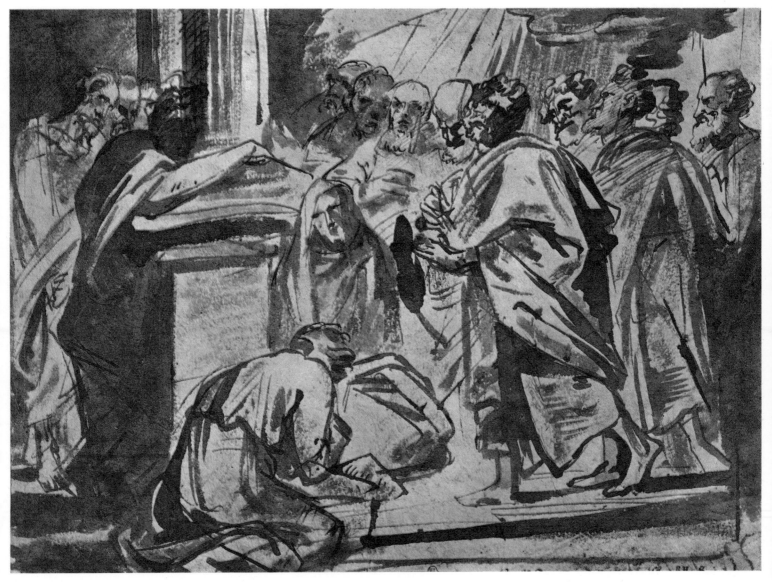

<div align="center">

Plate 42

Anthony van DYCK · *The Descent of the Holy Ghost* · pen and brush in brown, 207 x 280 mm. · Paris, Louvre

</div>

Plate 41

Anthony van DYCK · *The Entombment* · pen and brush with brown ink, washed in dark lilac, red and greenish tints,
corrected with white body-color and touched with white, 256 x 218 mm.
Chatsworth, Devonshire Collection, Reproduced by permission of the Trustees of the Chatsworth Settlement

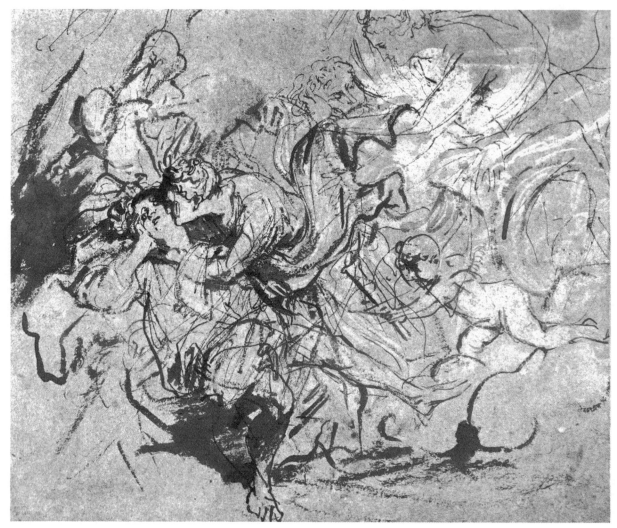

Plate 43

Anthony van DYCK • *Diana and Endymion* • pen and brush, heightened with white, on blue-gray paper
190 x 229 mm. • New York, Pierpont Morgan Library

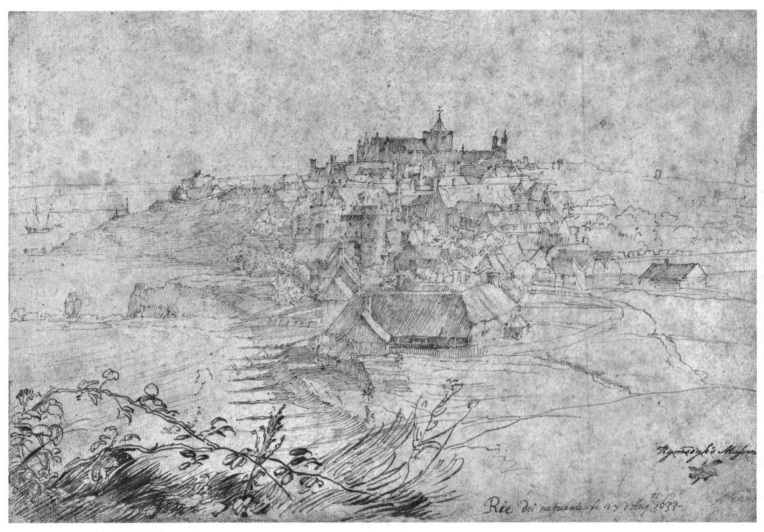

Plate 44

Anthony van DYCK · *View of Rye* · pen and brown ink, 202 x 294 mm. · New York, Pierpont Morgan Library

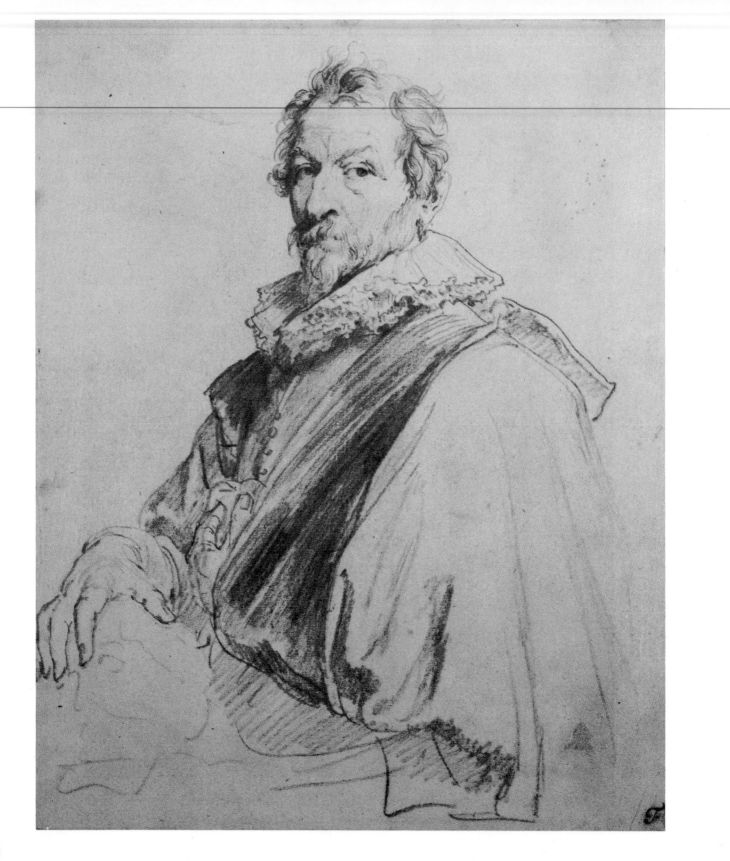

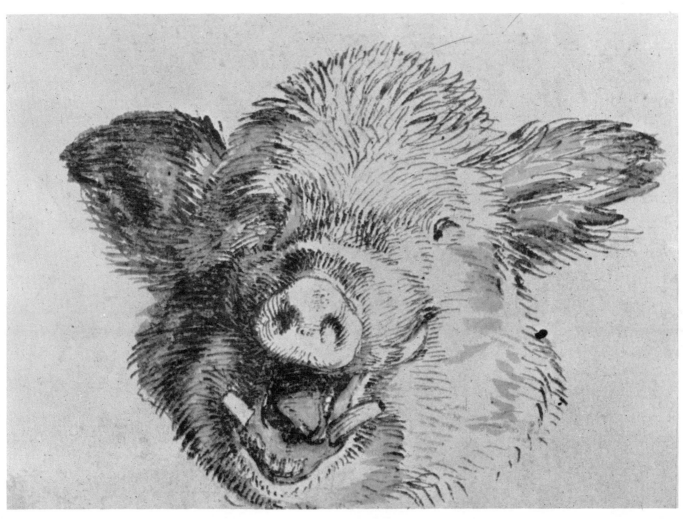

Plate 46
Frans SNYDERS · *Study of a Boar's Head* · pen in brown and brown wash, 128 x 185 mm. · London, The British Museum

Plate 45
Anthony van DYCK · *Portrait of Hendrik van Balen* · black chalk, 243 x 198 mm. · Chatsworth, Devonshire Collection
Reproduced by permission of the Trustees of the Chatsworth Settlement

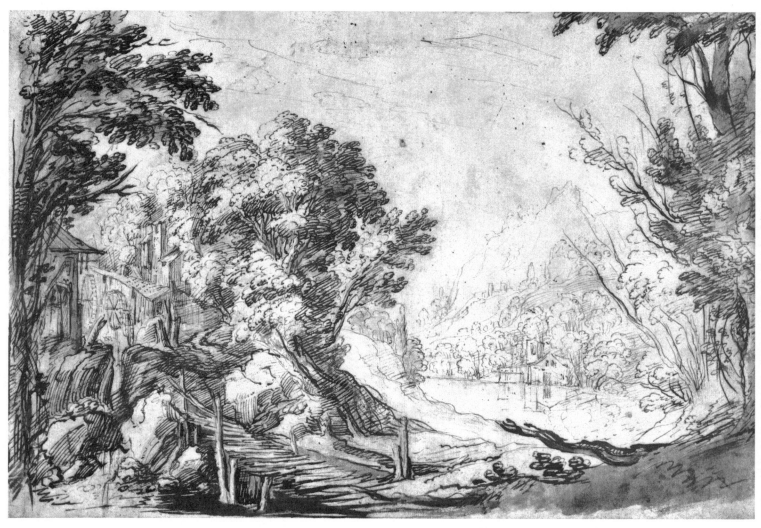

Plate 47

Paul BRILL · *Wooded Ravine with River View* · sepia, pen and wash, 206 x 327 mm. · New York, The Lehman Collection

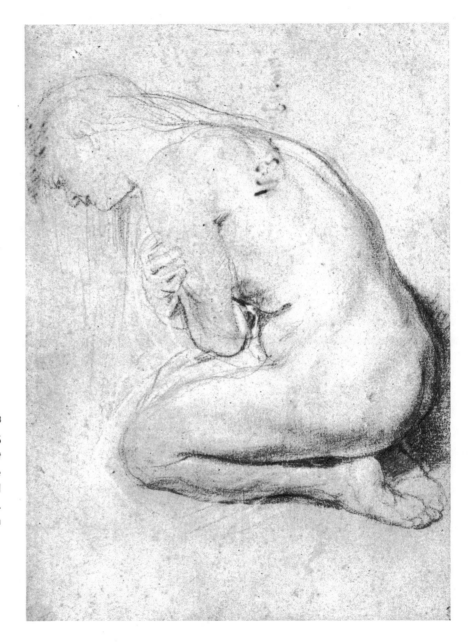

Plate 48

Peter Paul RUBENS
*Study for a Saint
Mary Magdalene*
Black chalk, heightened
with white, 332 x 242 mm.
London, The British Museum

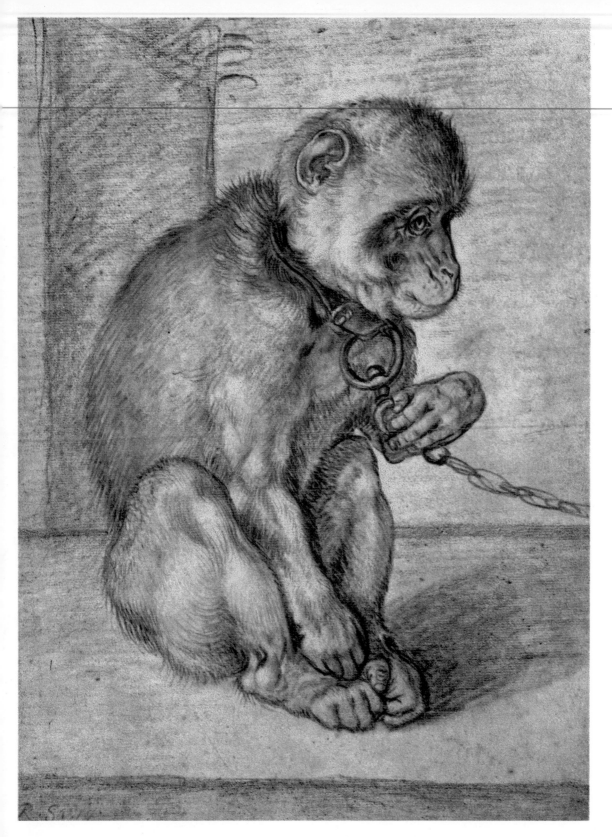

Plate 49

Roelant Jacobs SAVERY
A Young Monkey
black, red and yellow chalk
and brush
406 x 300 mm.
Amsterdam, Rijksmuseum

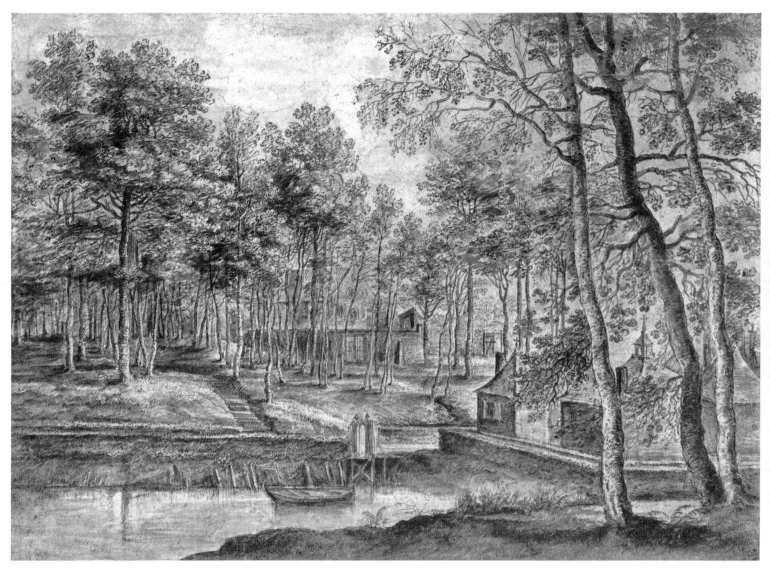

Plate 50

Lucas van UDEN • *Woodland with Monastic Buildings* • pen and brown ink, gray wash and body-colors, 221 x 310 mm.
New York, Pierpont Morgan Library

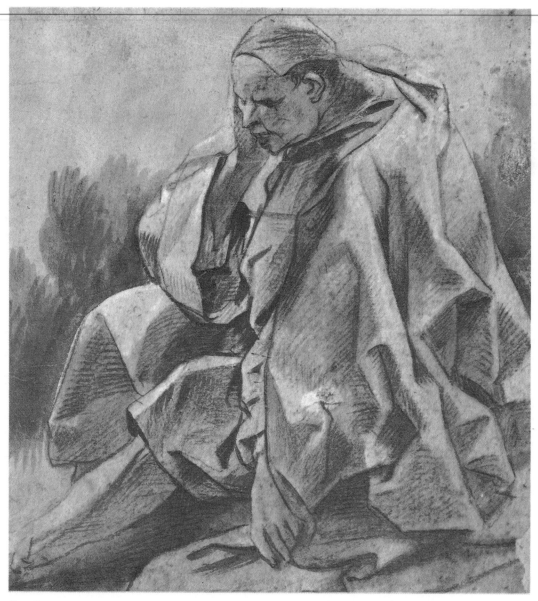

Plate 51

Jacob JORDAENS • *A Study of a Seated Man* • brush in brown and gray over black chalk
285 x 267 mm. • Los Angeles County Museum

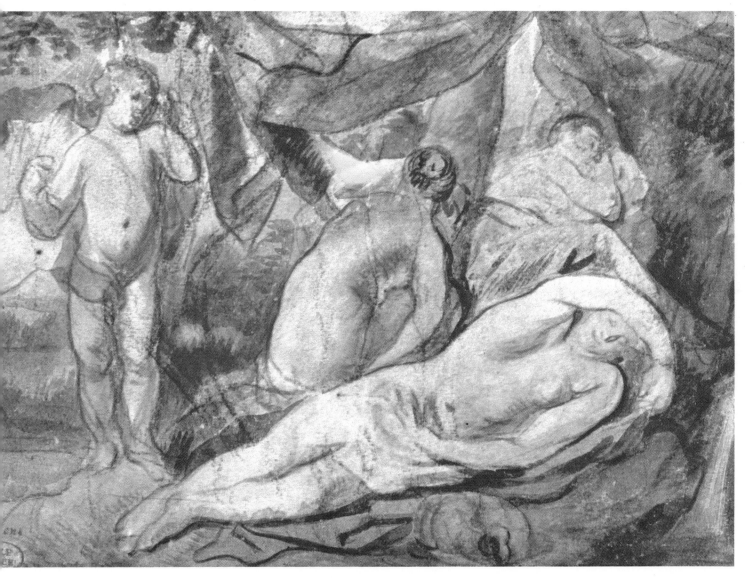

Plate 52

Jacob JORDAENS · *Venus Sleeping* · brush and brown ink, water color and red chalk over black chalk, 173 x 267 mm.
Lille, Palais des Beaux-Arts, Musée Wicar

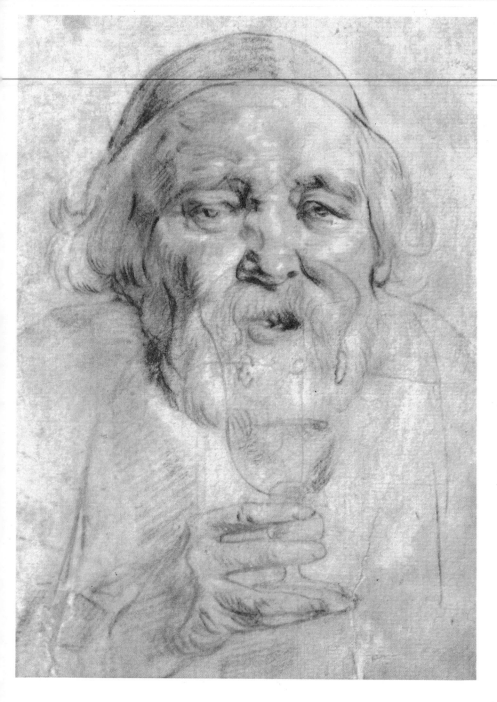

Plate 53

Jacob JORDAENS
Head of an Old Man Drinking
(Portrait of Adam van Noort)
black and red chalk, heightened with white
187 x 136 mm.
Cambridge, Fitzwilliam Museum
Reproduced by permission of The Syndics
of the Fitzwilliam Museum, Cambridge

Plate 54

Adriaen BROUWER • *Studies of Peasants* • pen and brown ink over pencil, 215 x 328 mm.
Berlin, Kupferstichkabinett

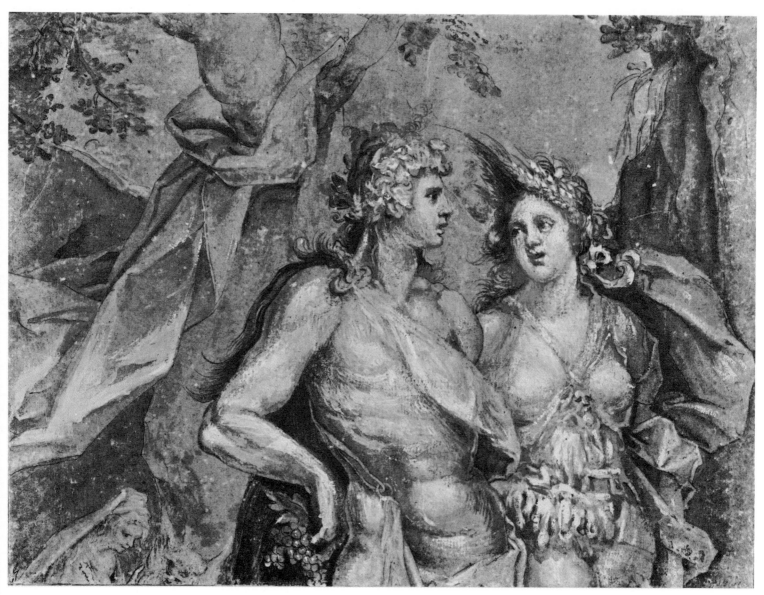

Plate 55

Hendrick Goltzius · *Bacchus and Ceres* · Chalk and wash heightened with white, 285 x 381 mm. · London, The British Museum

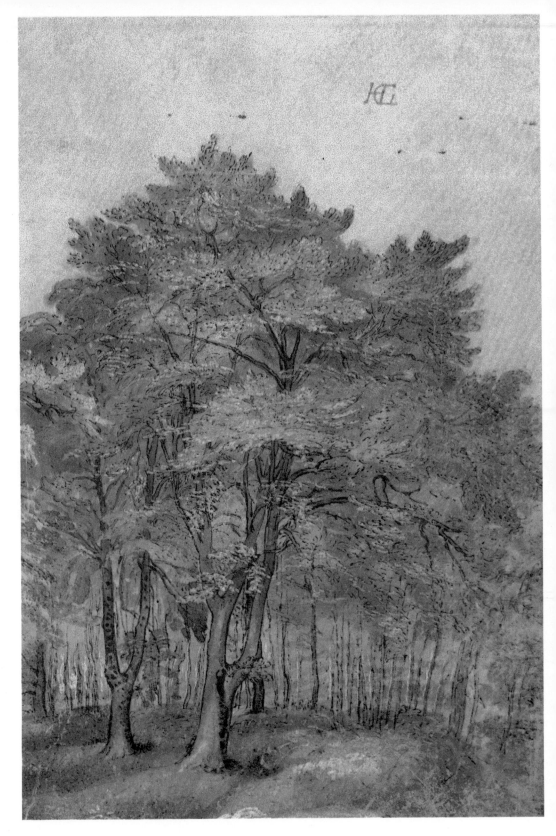

Plate 56

Hendrick GOLTZIUS
Group of Trees in a Wood
pen and brown ink with touches
of color on blue-tinted paper
284 x 200 mm.
Hamburg, Kunsthalle

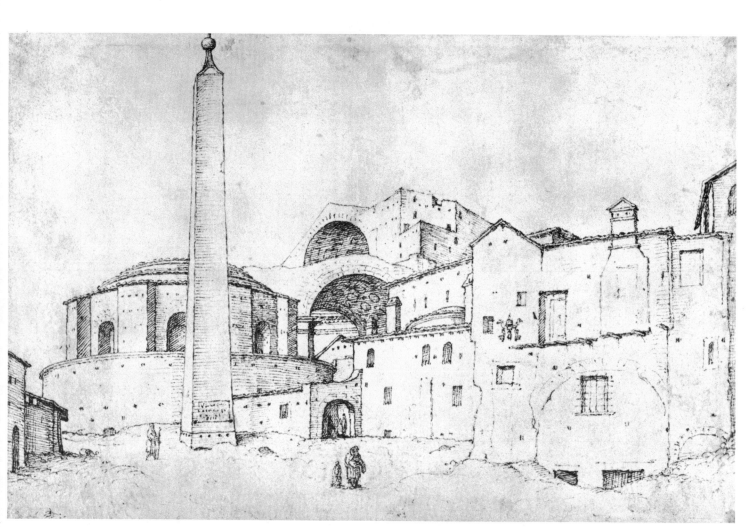

Plate 57

Marten van HEEMSKERCK · *Obelisk of St. Peter's near St. Peter's and Santa Maria delle Febre* · pen and ink, 129 x 200 mm.
Berlin, Kupferstichkabinett

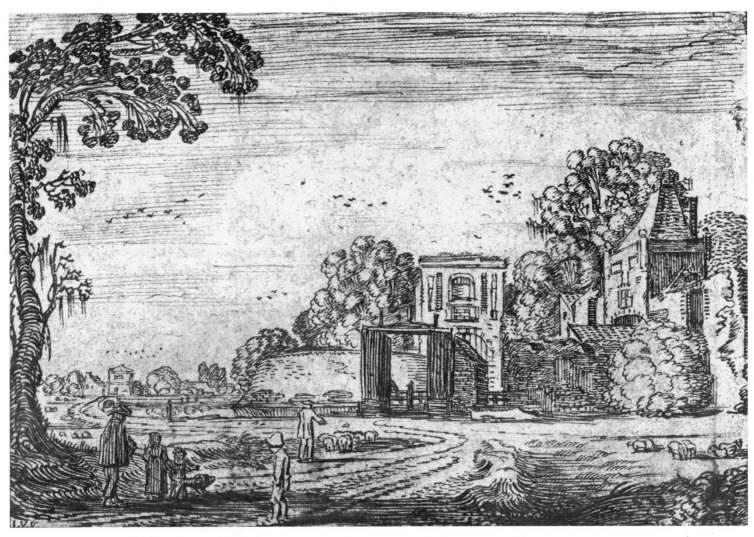

Plate 58

Jan van de VELDE · *Zilpoort in Haarlem* · pen and ink, 141 x 208 mm. · Munich, Staatliche Graphische Sammlung

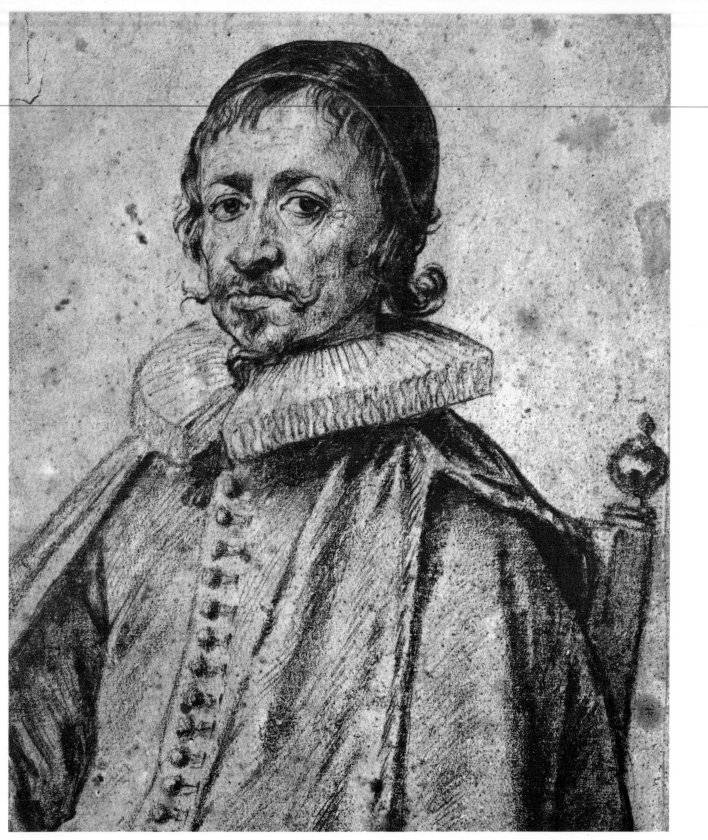

90

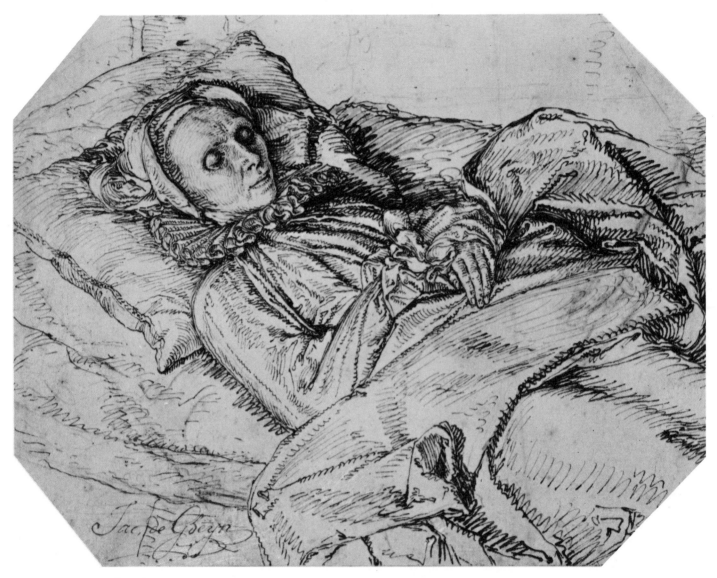

Plate 60

Jacques de GHEYN the Younger · *Woman on Her Deathbed* · pen and brown ink, 146 x 194 mm.
Amsterdam, Rijksmuseum

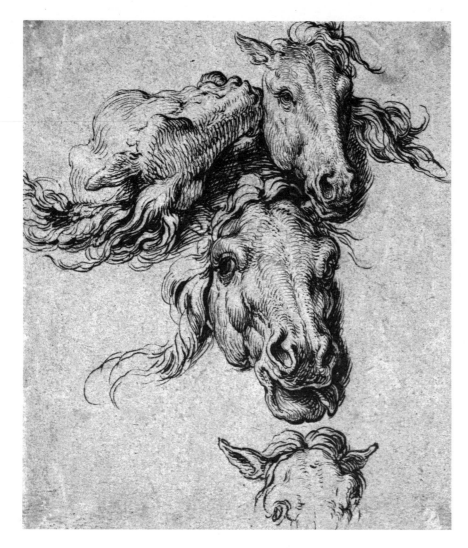

Plate 61

Jacques de GHEYN the Younger
Four Heads of a Horse
pen and brown ink, black chalk
250 x 215 mm.
Berlin, Kupferstichkabinett

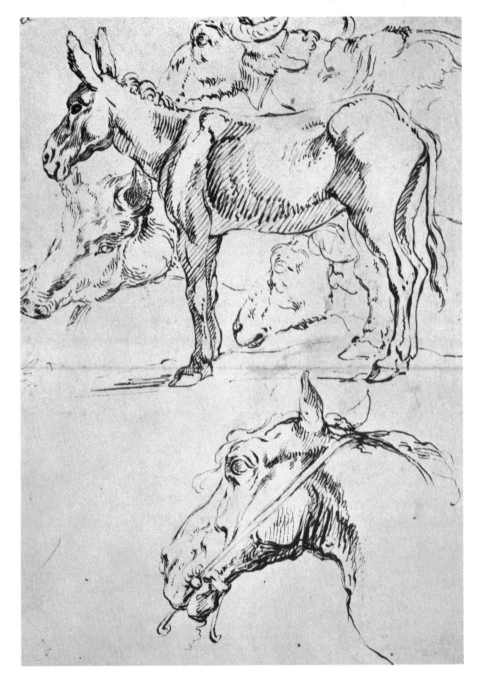

Plate 62
Pieter van LAER
called Bamboccio
*Studies of a Donkey and
Other Animals*
pen and brown ink
222 x 158 mm.
Oxford, Ashmolean Museum

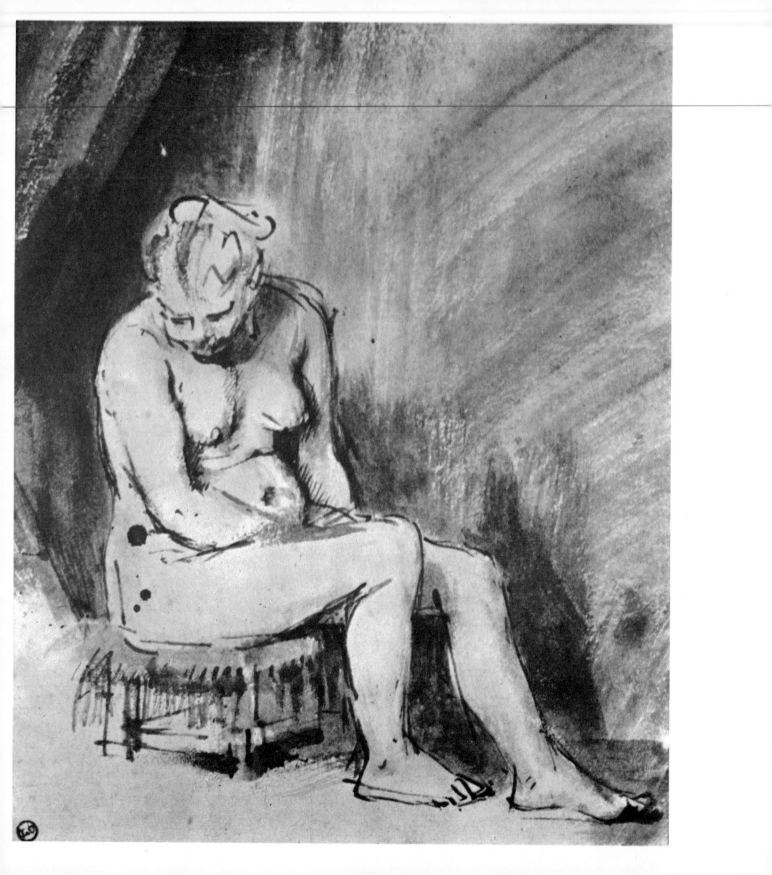

Plate 64

REMBRANDT van Rijn
Portrait of Saskia in a Turban
black chalk and brown wash,
on grayish paper, 195 x 140 mm.
Bayonne, Musée Bonnat

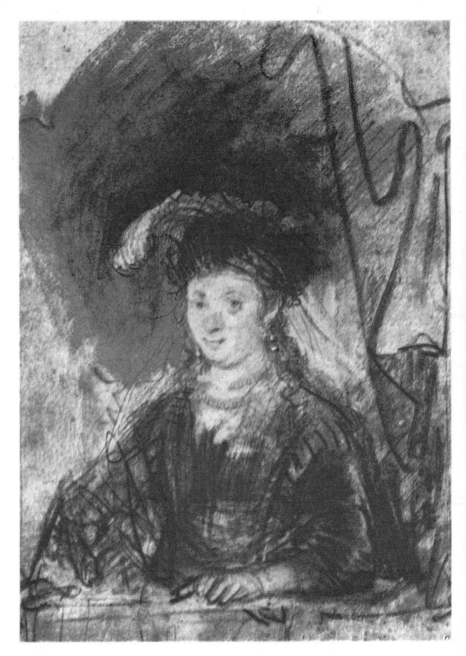

Plate 63

REMBRANDT van Rijn
Female Nude Sitting on a Stool
pen and brown ink
washed in sepia, 211 x 174 mm.
Chicago, The Art Institute

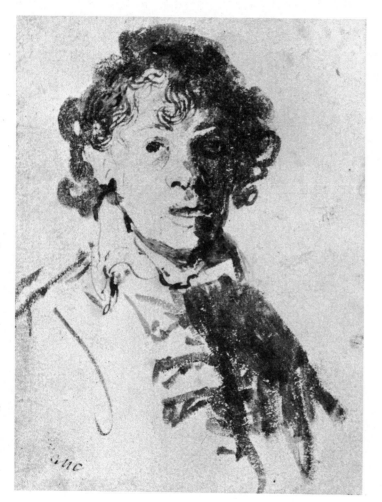

Plate 65

REMBRANDT van Rijn
Self-Portrait
pen and brown ink,
brush and India ink
127 x 95 mm.
London, The British Museum

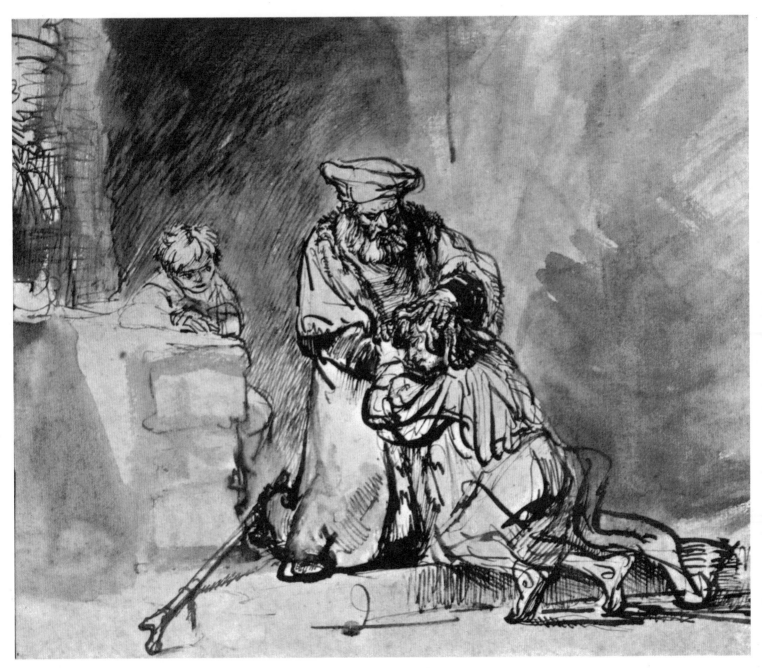

Plate 66

REMBRANDT van Rijn • *The Return of the Prodigal Son* • pen and brown ink, wash and corrections with white body-color
209 x 227 mm. • Haarlem, Teyler Museum

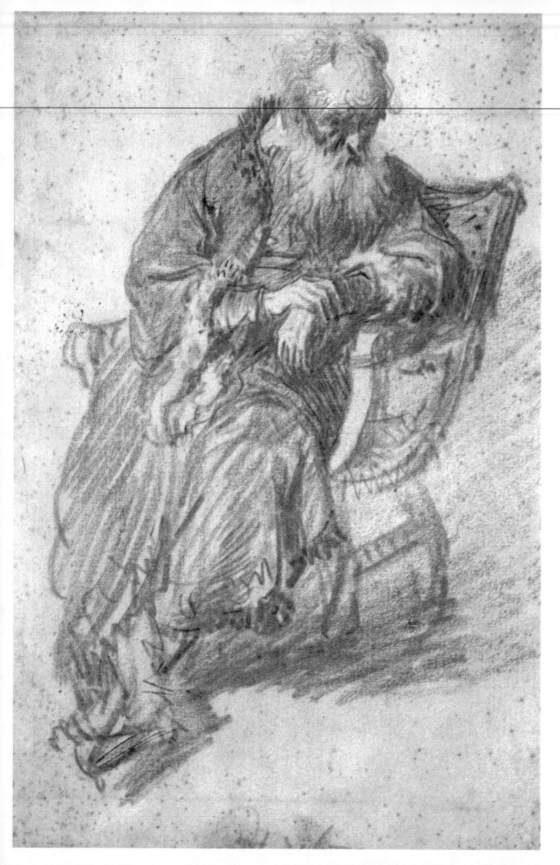

Plate 67

REMBRANDT van Rijn
Old Man Seated in an Armchair
red and black chalk
225 x 145 mm.
Haarlem, Teyler Museum

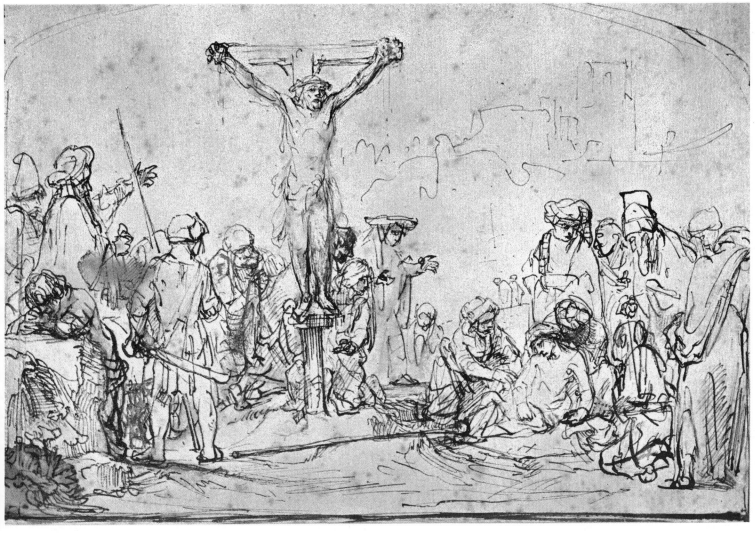

Plate 68

REMBRANDT van Rijn • *The Crucifixion* • pen and wash, corrections with bistre and white, 165 x 239 mm.
Frankfort-on-Main, Staedel Art Institute

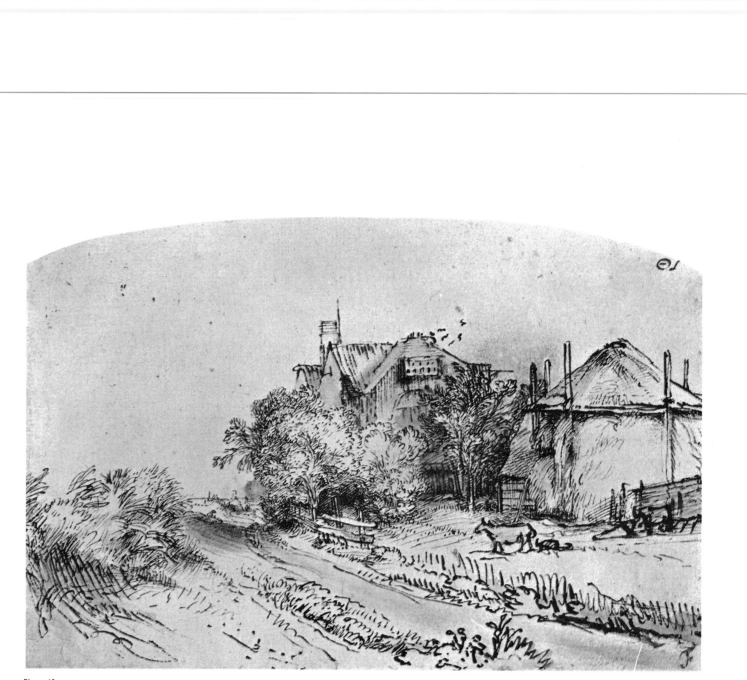

Plate 69

REMBRANDT van Rijn · *A Farm on a Country Road* · pen and brown ink, wash, arched at top, 128 x 200 mm.
Chatsworth, Devonshire Collection, Reproduced by permission of the Trustees of the Chatsworth Settlement

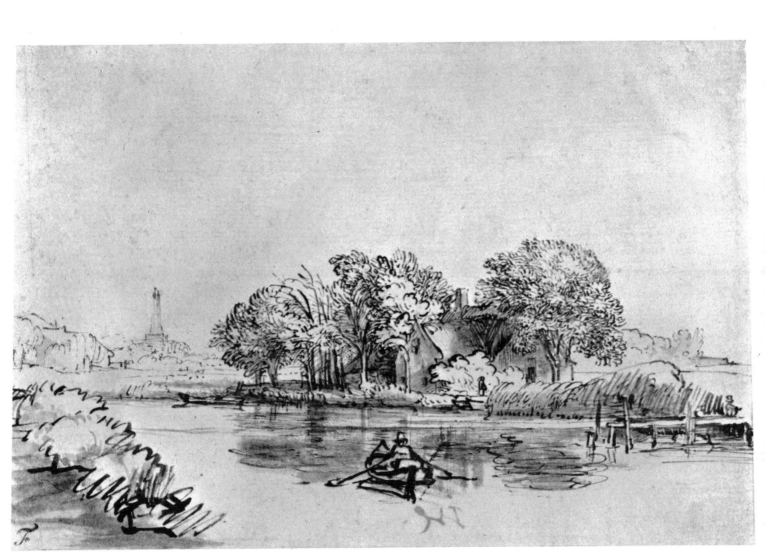

Plate 70

REMBRANDT van Rijn · *A Farm on the Waterfront* · pen in brown ink, wash, and white body-color, 133 x 204 mm.
Chatsworth, Devonshire Collection, Reproduced by permission of the Trustees of the Chatsworth Settlement

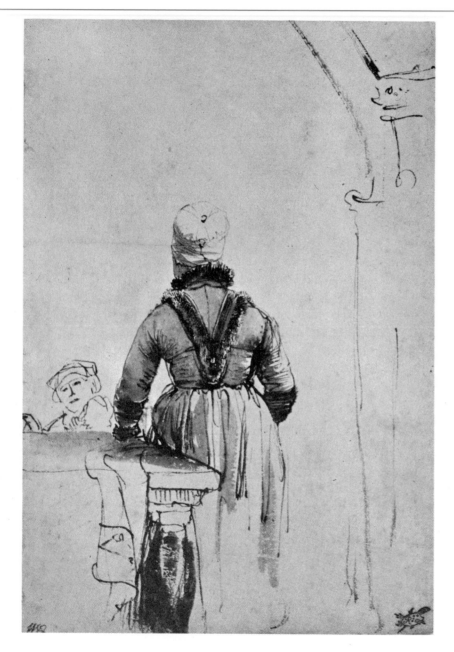

Plate 71
REMBRANDT van Rijn
Woman in North-Holland
Costume, Seen from the Back
pen and brown ink and wash
220 x 150 mm.
Haarlem, Teyler Museum

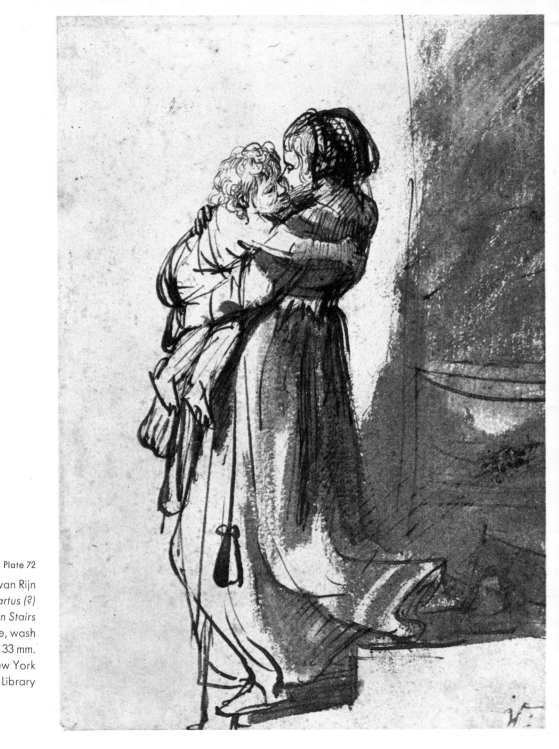

Plate 72
REMBRANDT van Rijn
Saskia Carrying Rumbartus (?)
Down Stairs
pen and bistre, wash
187 x 133 mm.
New York
Pierpont Morgan Library

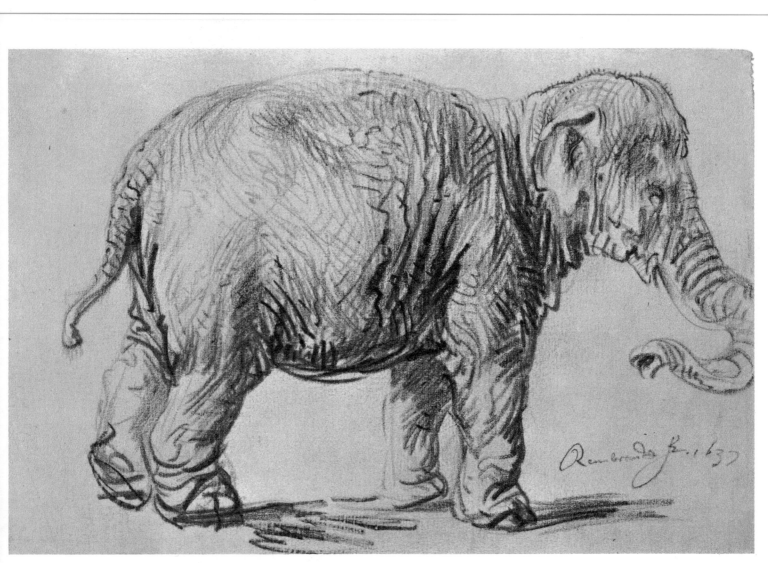

Plate 73
REMBRANDT van Rijn • *An Elephant* • black chalk, 233 x 354 mm. • Vienna, Albertina Gallery

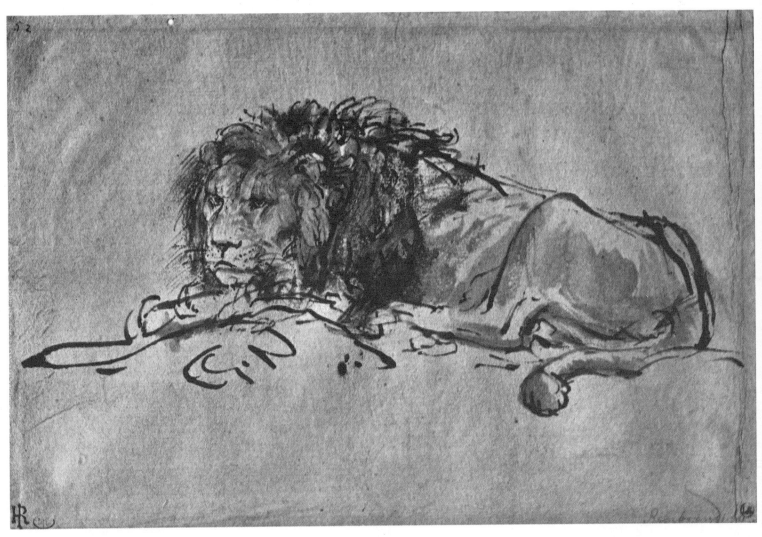

Plate 74

REMBRANDT van Rijn • *Lion Resting* • pen and brush in brown ink, 138 x 207 mm. • Paris, Louvre

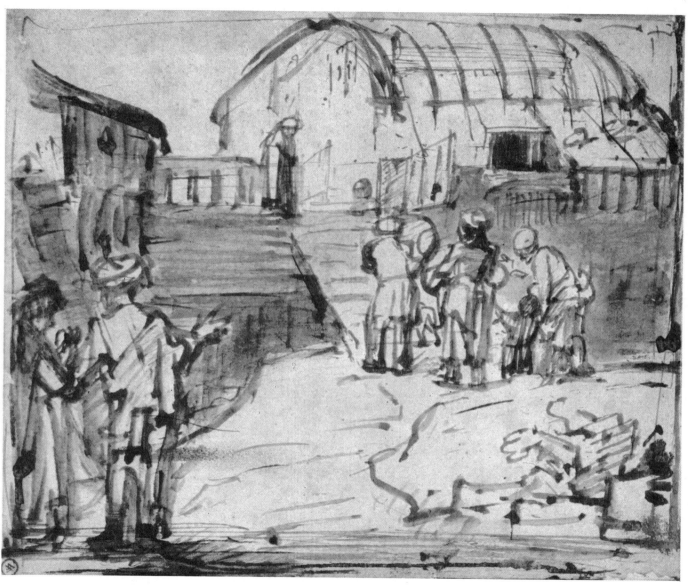

Plate 75

REMBRANDT van Rijn • *Noah's Ark* • reed pen and brown ink and brush, 199 x 243 mm. • Chicago, The Art Institute

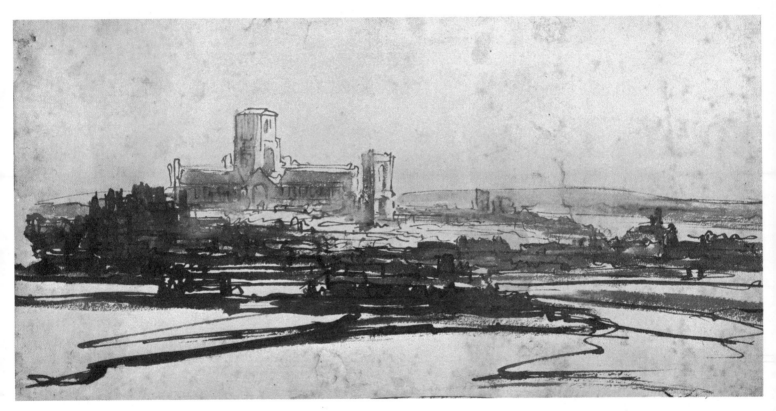

Plate 76

REMBRANDT van Rijn • *Panorama of London, with Old St. Paul's* • pen and brown ink, heightened with white, 164 x 318 mm.
Berlin, Kupferstichkabinett

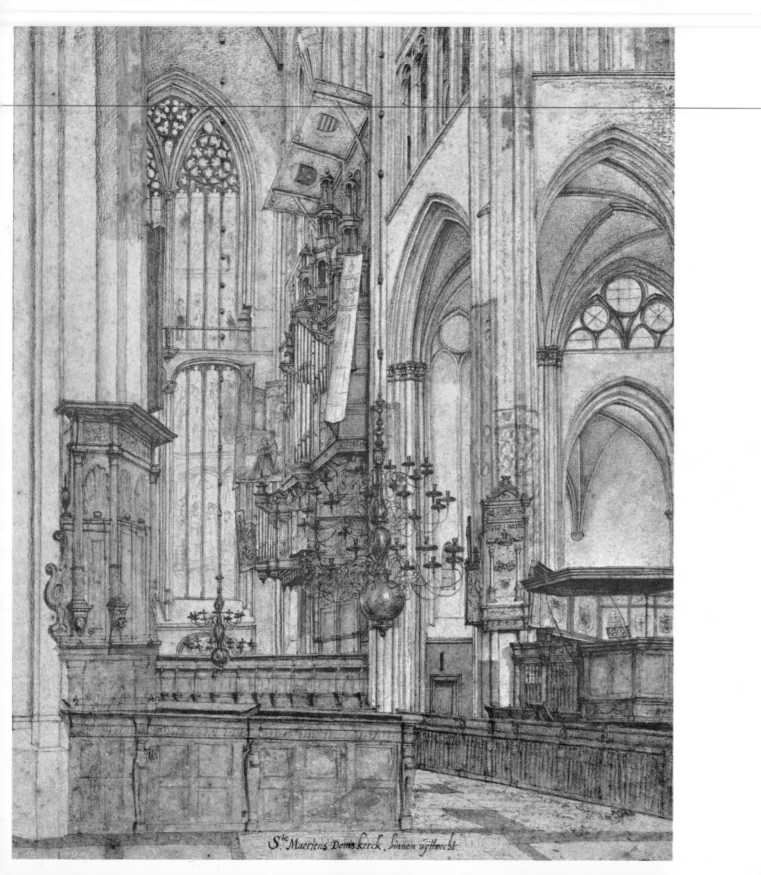

Ste Maertens Doms kerck, binnen uijtrecht.

Plate 78

Allaert van EVERDINGEN • *Study for Apostle's Ships at Sea* • brush and brown wash over slight indication in black crayon
152 x 208 mm. • Cambridge, Mass., Harvard University, Fogg Art Museum

Plate 77

Pieter SAENREDAM • *Interior of Saint Catherine's Church at Utrecht (Detail)* • Black chalk and pen in brown, water colors,
302 x 393 mm. • Utrecht, Gemeente Archief

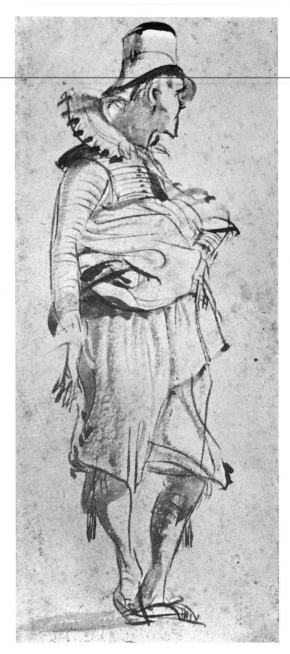

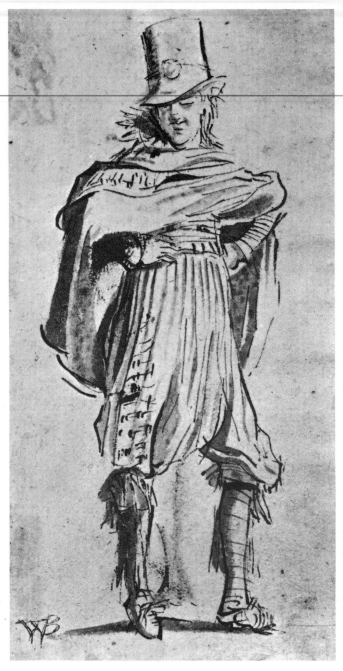

Plate 79

Willem Pieterz BUYTEWECH
Study of a Young Man Standing
pen and pencil in light brown, 165 x 75 mm.
Berlin, Kupferstichkabinett

Plate 80

Willem Pieterz BUYTEWECH
Study of a Young Man Standing
pen in dark brown, grayish-brown pencil, 170 x 92 mm.
Berlin, Kupferstichkabinett

Plate 81

Adriaen van OSTADE · *Peasants Dancing* · black chalk, pen and brush with brown ink, 208 x 164 mm. · Haarlem, Teyler Museum

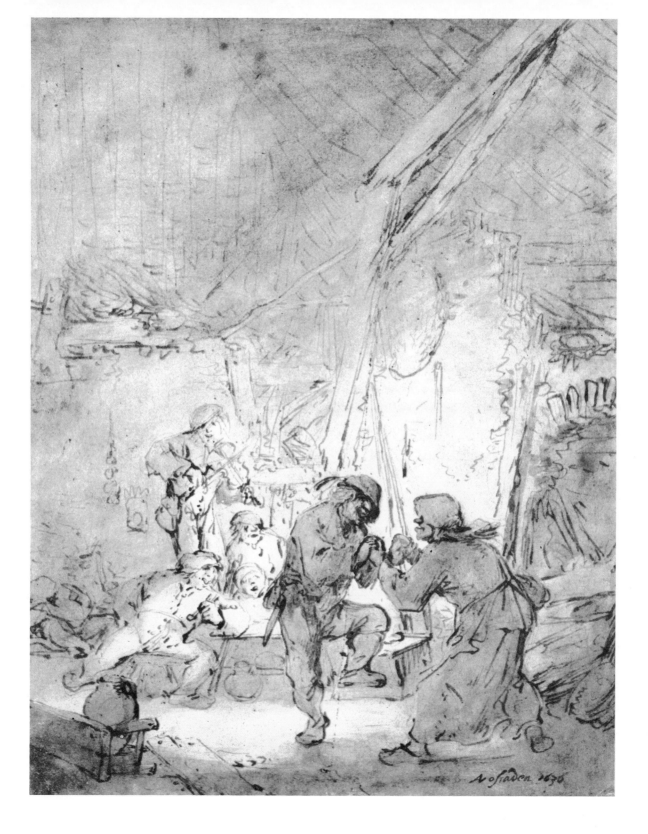

111

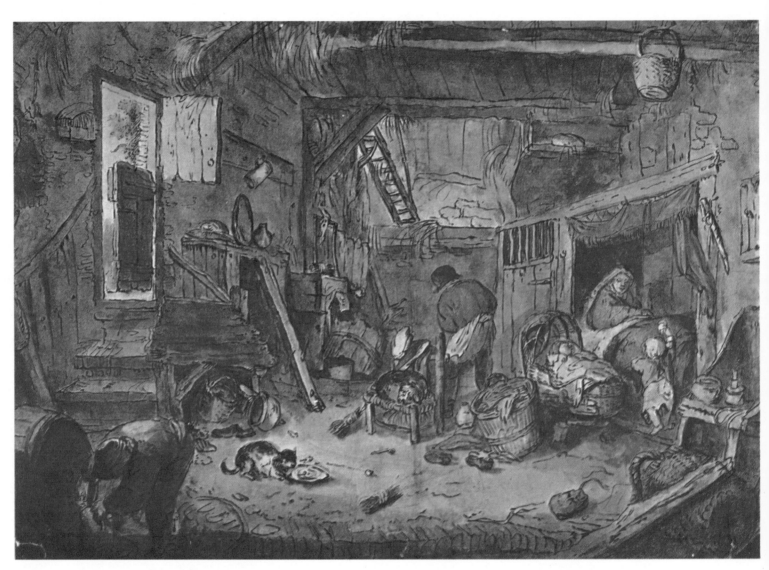

Plate 82

Adriaen van OSTADE · *Interior of a Barn* · pen and sepia and India ink with water color, 270 x 381 mm.
New York, The Lehman Collection

Plate 83

Adriaen van OSTADE · *The Letter* · bistre, pen and ink over black chalk and wash on dark bluish paper, 217 x 190 mm.
Berlin, Kupferstichkabinett

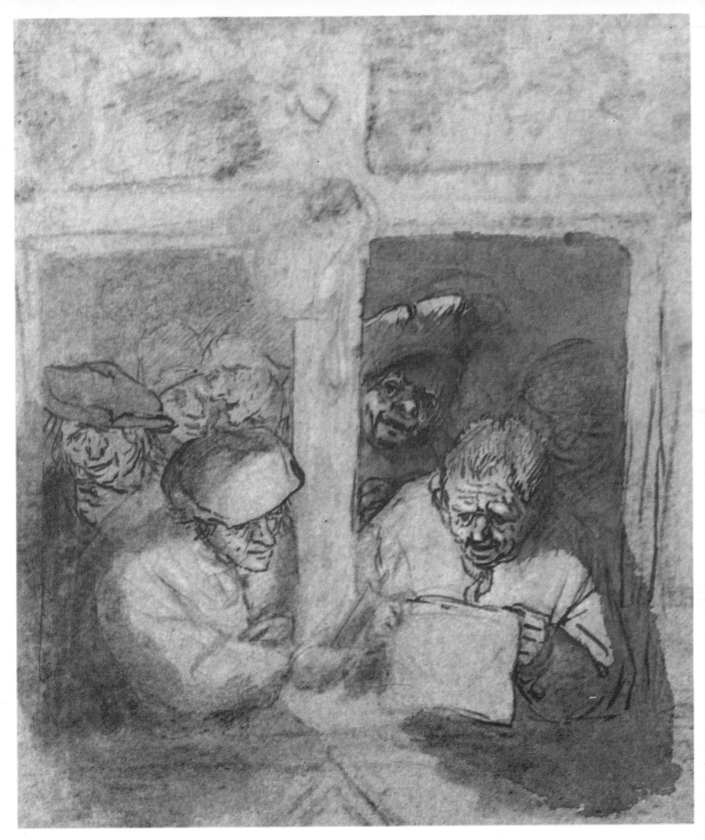

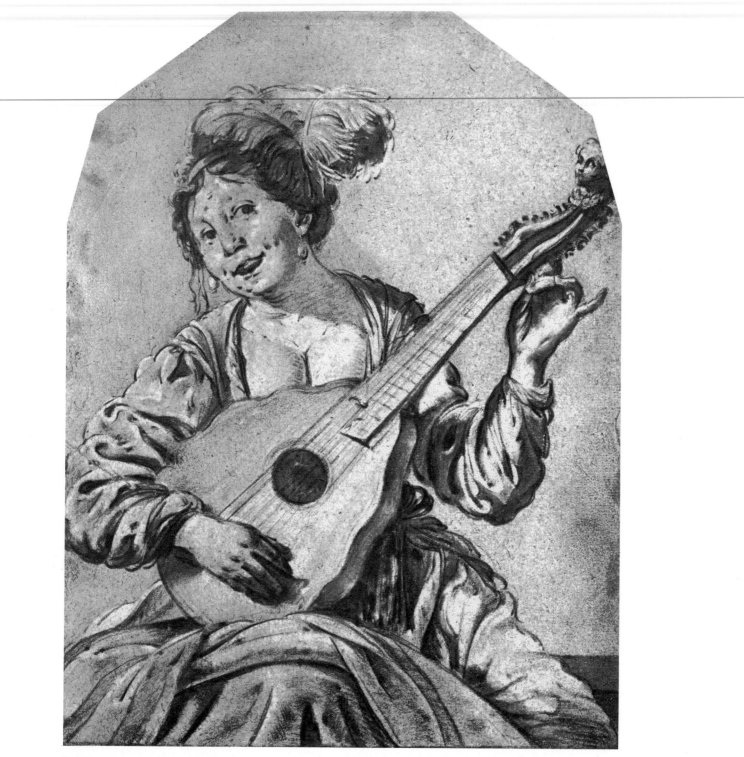

Plate 84

Hendrick TERBRUGGHEN • *Woman Playing the Penorcon* • India ink and white chalk on gray paper
257 x 204 mm. • Hamburg, Kunsthalle

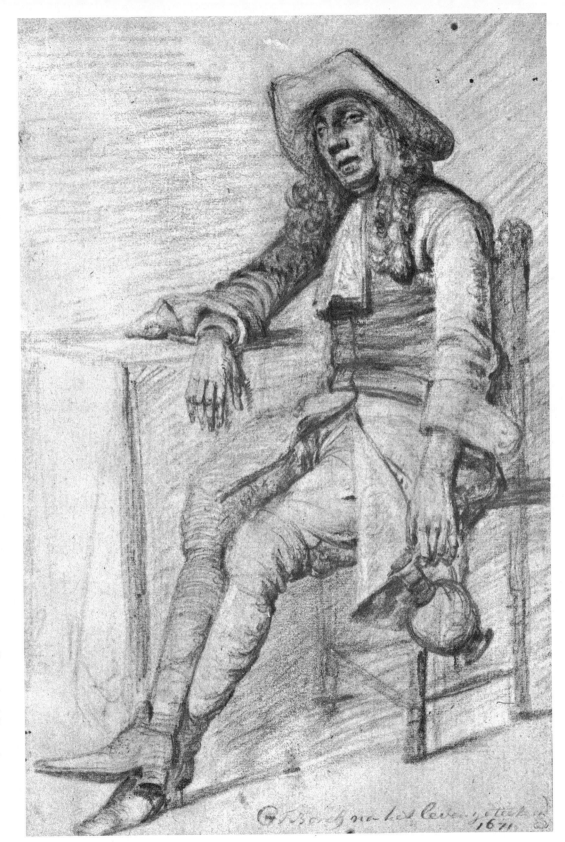

Plate 85
Gerard TERBORCH
the Younger
Portrait of Seated Man,
Jug in Hand
Black chalk, 305 x 203 mm.
Vienna, Albertina Gallery

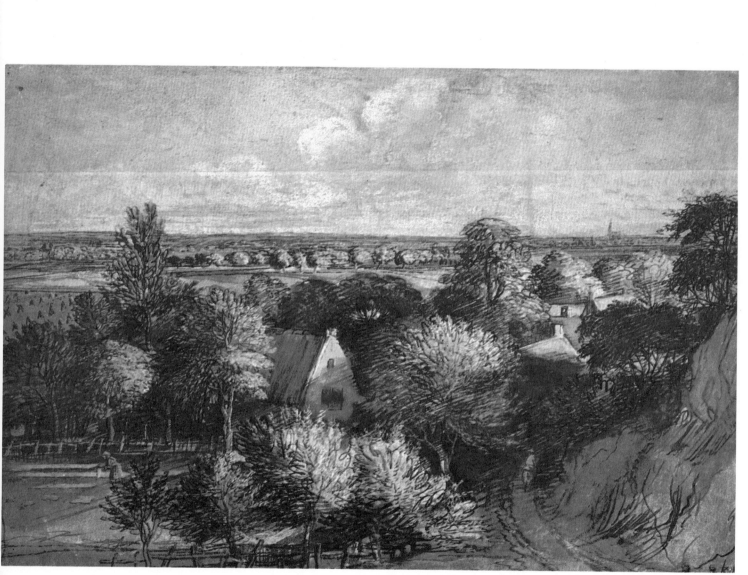

Plate 86

Philips de KONINCK · *Landscape with Houses amidst Trees* · pen and brown ink, brown and gray wash, heightened with white
250 x 290 mm. · Leningrad, Hermitage

116

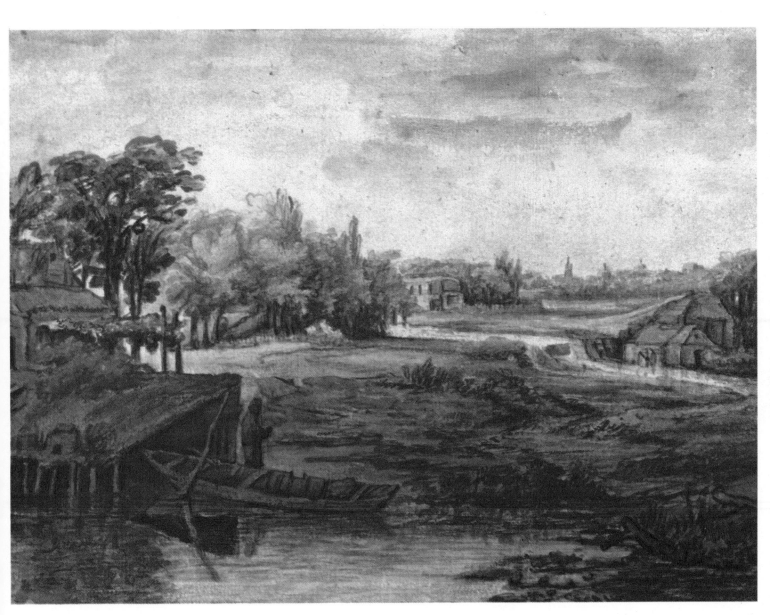

Plate 87

Philips de KONINCK · *Landscape with Boathouse* · pen and brown ink, with water color, 156 x 224 mm.
New York, Harry G. Sperling

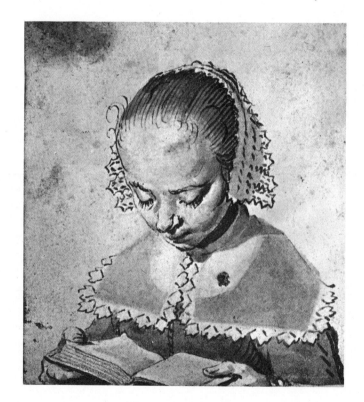

Plate 88
Gerard TERBORCH the Elder
Young Girl Reading a Book
pen and wash in gray and brown,
red chalk, 97 x 89 mm.
Amsterdam, Rijksmuseum

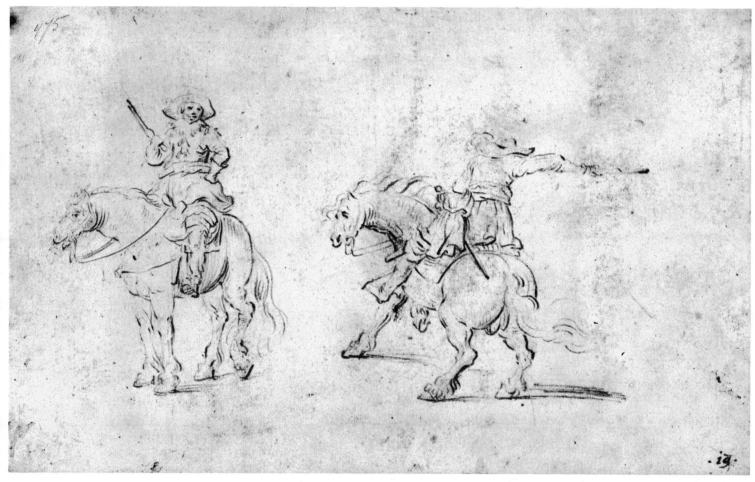

Plate 89

Gerard TERBORCH the Younger • *Two Men on Horseback* • pencil, black chalk and pen in brown, 191 x 305 mm.
Amsterdam, Rijksmuseum

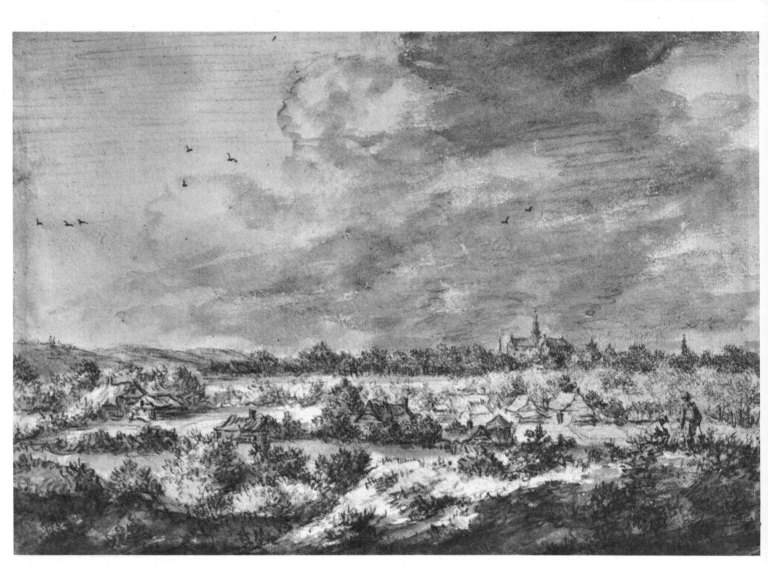

Plate 90

Jacob van RUISDAEL • *View of Haarlem* • black chalk, brush with gray ink, 164 x 239 mm. • Paris, Louvre

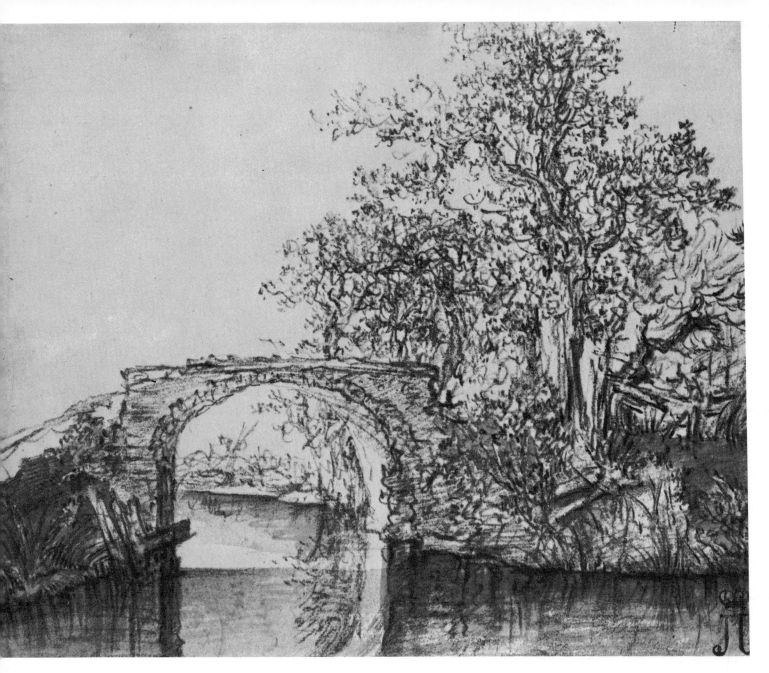

Plate 91

Jacob van RUISDAEL · *Landscape with a Stone Bridge* · black chalk and brush in gray, 165 x 205 mm. · Leningrad, Hermitage

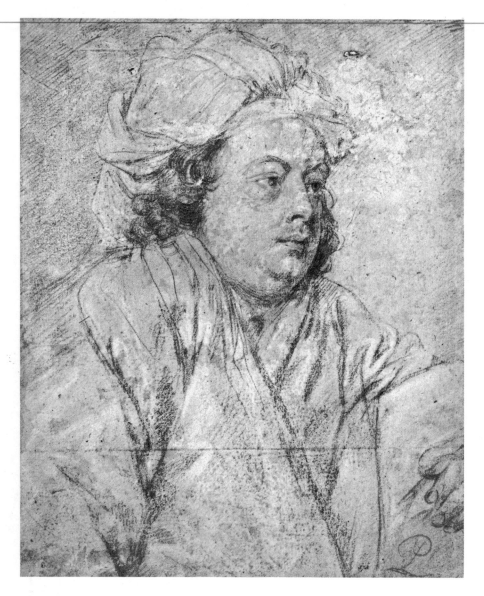

Plate 92

Sir Peter LELY
Portrait of a Man in a Turban
black and red chalk
400 x 350 mm.
London, Victoria and
Albert Museum

Plate 93

Willem van de VELDE the Younger · *Ships Saluting in a Calm* · pen and brown ink, wash, over black chalk, 143 x 335 mm.
Lille, Palais des Beaux-Arts, Musée Wicar

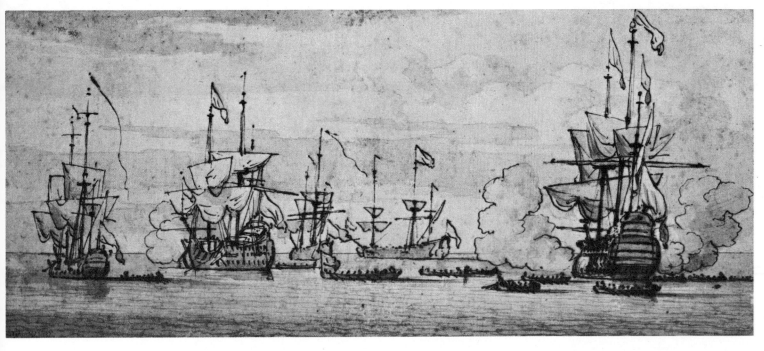

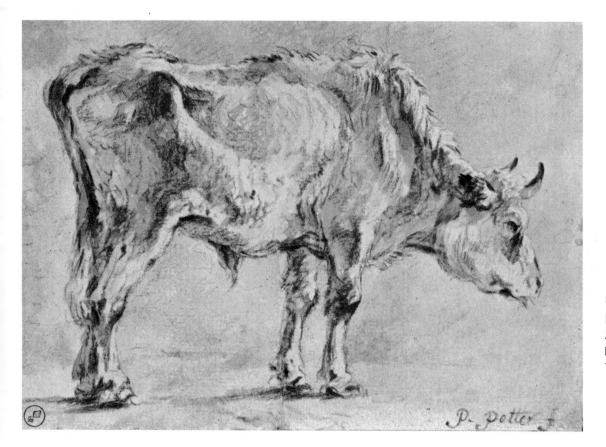

Plate 94

Paulus POTTER
Study of a Bull
black pencil, 126 x 155 mm.
Turin, Biblioteca Reale

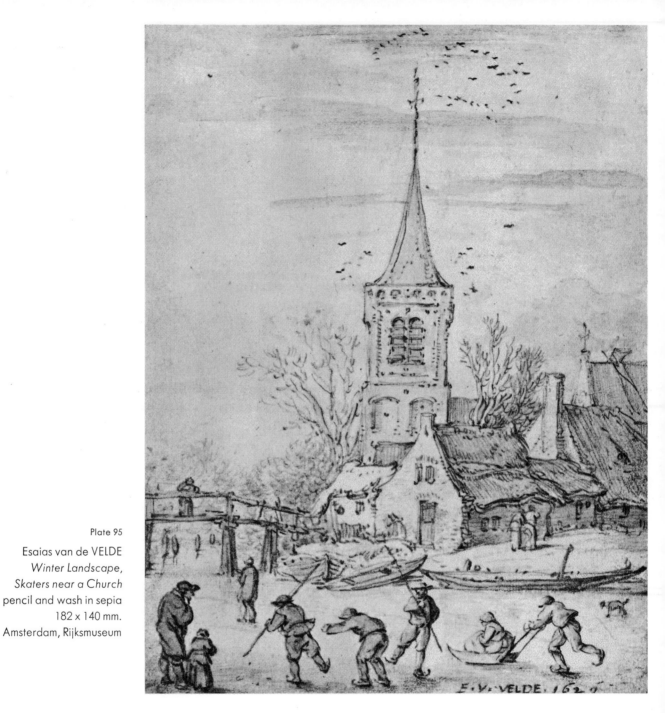

Plate 95

Esaias van de VELDE
*Winter Landscape,
Skaters near a Church*
pencil and wash in sepia
182 x 140 mm.
Amsterdam, Rijksmuseum

125

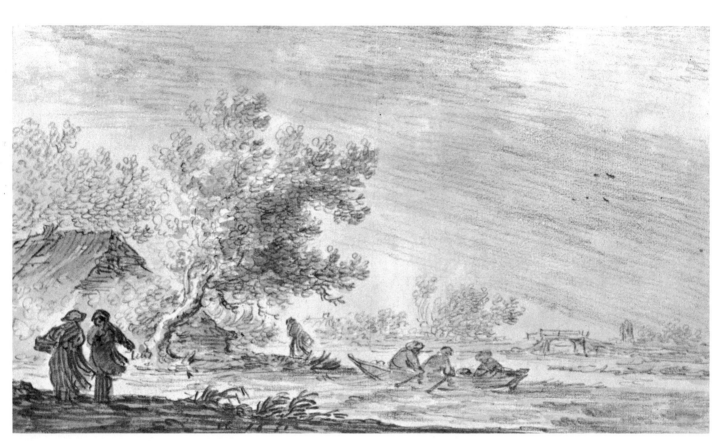

Plate 96

Jan van GOYEN • *Landscape Near a River* • black chalk, wash, 110 x 195 mm. • Berlin, Kupferstichkabinett

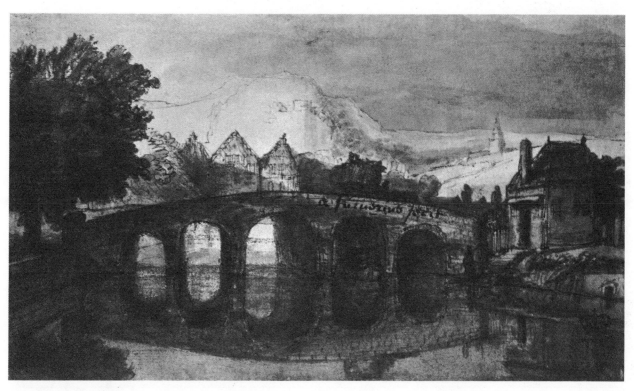

Plate 97

Abraham FURNERIUS · *Landscape with a Bridge* · pen and brown ink and brown wash, heightened with white
100 x 170 mm. · Leningrad, Hermitage

Biographies

BEER, Jan de
Jan de Beer (ca. 1475-ca. 1536) worked at Antwerp, was a contemporary of Mabuse and became Dean of the Antwerp Guild in 1515.

BLOEMAERT, Abraham
Abraham Bloemaert (1564-1651) was a Utrecht Mannerist who was strongly influenced by Caravaggio. He was the master of Cuyp, Honthorst, Terbrugghen, and Weenix. He painted religious and mythological scenes and landscapes.

BOSCH, Hieronymous
Hieronymous Bosch (1460/62-1516/18) was a Flemish painter best known for his fanciful religious allegories, although he also did satirical genre subjects. He represented the medieval belief in witchcraft and diabolism yet was modern in that his looseness of style marked the end of medieval painting.

BOUTS, Dirk
Dirk Bouts (1410/20-1475) was one of the most important primitive painters in Flanders. Although there are no drawings firmly attributed to him there are a number of silverpoint drawings closely related to his paintings.

BRILL, Paul
Paul Brill (1554/56-1626) was a Flemish painter of landscapes and religious themes who retained his native style although he worked in Rome.

Plate 98
Jan van HUYSUM · *Flower Piece* · pen and brown ink, charcoal and water color, 408 x 318 mm.
Shawnee Mission, Kansas, Mr. and Mrs. Milton McGreevy

BROUWER, Adriaen

Adriaen Brouwer (1605/8-1638) was the link between Flemish and Dutch genre painting. In 1631/2 he was in the Guild in Antwerp and influenced by Rubens. His pictures represent peasant and tavern scenes.

BRUEGEL, Pieter, the Elder

Pieter Bruegel the Elder (1525-1569) was a Flemish painter of landscape and of peasants whom he portrayed naturally. He also did religious scenes and moral subjects in an unconventional manner. He was greatly influenced by Hieronymous Bosch and by his own observations of nature in his travels.

BRUEGHEL, Jan, the Elder

Jan Brueghel the Elder (1568-1625), called "Velvet Brueghel", was the son of Pieter Bruegel the Elder. He worked with Rubens.

BUYTEWECH, Willem Pieterz

Willem Pieterz Buytewech (1590/2-1624/30) was a Dutch painter and etcher of genre and historical subject matter. His costumed figures are among the most well-known aspects of his work.

CHRISTUS, Petrus

Petrus Christus (ca. 1400-1472/73) was a Netherlandish painter and a pupil of Jan van Eyck and was also influenced by Meister Flemalle. He painted religious and genre scenes and portraits.

DAVID, Gerard

Gerard David (ca. 1460-1523) was a Netherlandish painter who was influenced by Memling. Recording the real world, he also made contributions to landscape painting. His painting marked the end of the Primitive style.

DYCK, Anthony van

Anthony van Dyck (1599-1641) was a Flemish painter and Rubens' favorite pupil. He was influenced by Rubens and traveled to Italy. In London he became British Court Painter and is best known for his portraits.

ENGELBRECHTSEN, Cornelis

Cornelis Engelbrechtsen (1468-1533) was a painter of the early Dutch Renaissance school. He worked in Leyden all his life, where he was the teacher of Lucas van Leyden.

EVERDINGEN, Allaert van

Allaert van Everdingen (1621-1657) was a Dutch landscape painter. After visiting Scandinavia (1640-4), he returned to Holland with a new type of romantic mountain landscape—pine forests and waterfalls. He influenced some of the later works of Jacob van Ruisdael.

EYCK, Jan van

Jan van Eyck (1380/90-1441) was the most important early Netherlandish painter who, with his brother Hubert, was responsible for several innovations in Flemish art, including the establishment of panel painting and the perfection of oil painting technique.

FURNERIUS, Abraham

Abraham Funerius (ca. 1628-1654) was a pupil of Rembrandt and the brother-in-law of Philips de Koninck.

GHEYN, Jacques de, the Younger

Jacques de Gheyn the Younger (1565-1629), was a pupil of Goltzius who also trained him as an engraver.

GOES, Hugo van der

Hugo van der Goes (1440?-1482) was a very important early Netherlandish painter whose only authenticated painting is the famous Portinari Altarpiece, *Adoration of the Shepherds.*

GOLTZIUS, Hendrick

Hendrick Goltzius (1558-1617) was a Haarlem engraver. After 1600, he also did paintings and woodcuts which were printed in several colors.

GOYEN, Jan van

Jan van Goyen (1596-1656) was one of the most important Dutch landscape painters of the realist school before Jacob van Ruisdael. His earliest works show the influence of Esaias van de Velde and are characterized by a delicate sense of atmosphere, generally carried out in grayish-brown tone.

HEEMSKERCK, Marten van

Marten van Heemskerck (1498-1574) worked with Scorel in Haarlem and learned most of the Italianate manner from him before going to Italy in 1532. He made a large number of drawings of the antiquities and works of art in Rome.

HUYSUM, Jan van

Jan van Huysum (1682-1749) was a Dutch flower-painter. His pictures are very highly detailed with crowded compositions which were arranged against a light background—his own innovation.

JORDAENS, Jacob

Jacob Jordaens (1593-1678) was considered in his own time to be the next greatest Flemish painter to Rubens. He was famous chiefly for colorful genre scenes but painted a variety of subjects.

KONINCK, Philips de

Philips de Koninck (1619-1688) was a pupil of Rembrandt and later learned landscape painting from his brother, Jacob. The figures in his panoramic views are sometimes by Lingelbach or Adriaen van de Velde.

LAER, Pieter van, called Bamboccio

Pieter van Laer, known as Bamboccio (1592/95-1642), was born in Haarlem and lived a long time in Rome. His paintings of peasants, soldiers, and brigands became popular in Italy and were imitated by other Northern artists.

LELY, Sir Peter

Pieter van der Faes (1618-1680), called Sir Peter Lely, was born in Germany of Dutch parents and studied in Haarlem. He became a naturalized Englishman and painted numerous portraits at the court of Charles II.

LEYDEN, Lucas van

Lucas van Leyden (1494?-1533), a painter of the early Northern Renaissance, was better known as an engraver. He was successively influenced by Engelbrechtsen, Dürer, Mabuse, and Scorel.

LIEVENS, Jan

Jan Lievens (1607-1672/74), shared a studio with Rembrandt in Leyden. He went to England and to Antwerp where he was influenced by van Dyck and became a successful painter of portraits and allegories.

Jan Gossaert, called MABUSE

Jan Gossaert, called Mabuse (gl. 1503-ca. 1533) worked in Holland and Flanders and is called an Antwerp Mannerist because he introduced many Italian Renaissance elements into Flemish painting.

MEMLING, Hans

Hans Memling (ca. 1430-1494) was a Netherlandish painter of religious scenes whose works are best known for their gentleness and graceful charm. He was a pupil of and influenced by Rogier van der Weyden.

OSTADE, Adriaen van

Adriaen van Ostade (1610-1685) was a Haarlem genre painter and a pupil of Frans Hals. He was influenced by Rembrandt and Brouwer, especially the latter, in the sense that both painted similar peasant scenes.

POTTER, Paulus

Paulus Potter (1625-1654) was one of the most famous of the colorful landscape and animal painters of Holland. He studied with his father and Jakob de Wet at Haarlem. He became popular and successful by painting the massive horses and cattle of prosperous Amsterdam merchants.

REMBRANDT van Rijn

Rembrandt van Rijn (1606-1669) was a great Dutch painter and etcher whose most important contribution was his system of lights and shadows, which gave psychological emphases to his painting. This method and his excellent portraiture strongly influenced later Dutch art. An accomplished draughtsman, he used simple forms and a loose composition influenced by Italian art and Indian miniatures.

RUBENS, Peter Paul

Peter Paul Rubens (1577-1640) was a great Flemish painter who traveled in Spain and Italy and showed a marked Italian influence—especially of Titian and the Venetians—in his use of color. A prolific painter, he had a large studio with many pupils who worked on his paintings, Anthony van Dyck among them.

RUISDAEL, Jacob van
Jacob van Ruisdael (1628/29-1682) was a Dutch landscape painter and etcher, greatly influenced by van Everdingen. In his imaginative treatment of landscape he forecast the work of 19th-century painters—Constable, Corot, and Rousseau.

SAENREDAM, Pieter
Pieter Saenredam (1597-1665), the son of an engraver, was a Dutch artist who specialized in painting church interiors for which he made careful preparatory drawings.

SAVERY, Roelant Jacobs
Roelant Jacobs Savery (1576-1639) was a Flemish painter of landscapes, mythological scenes and animals.

SCOREL, Jan van
Jan van Scorel (1495-1562) was a pupil of Mabuse and the teacher of Marten van Heemskerck and Antonio Moro. He was the first Dutch painter to go to Italy.

SNYDERS, Frans
Frans Snyders (1579-1657) was a Flemish painter of animals and was an associate of Rubens painting fruit, flowers and animals in large compositions.

SPRANGER, Bartholomeus
Bartholomeus Spranger (1546-ca. 1627) was an Antwerp Mannerist who was greatly influenced by Correggio and Parmigianino in figure compositions and subjects.

TERBORCH, Gerard, the Elder
Gerard Terborch the Elder (1584-1662) was unsuccessful as an artist, but he forecast some of the genre developments in Dutch art and was the father of more talented artists.

TERBORCH, Gerard, the Younger
Gerard Terborch the Younger (1617-1681) was one of the most important of the so-called little masters of Dutch painting who created the great genre paintings of Holland.

TERBRUGGHEN, Hendrick
Hendrick Terbrugghen (1588-1629) was a pupil of Bloemaert and studied Caravaggio's work in Italy. He became a leading member of the School of Utrecht Mannerists.

UDEN, Lucas van
Lucas van Uden (1595-1672) was a Flemish painter and collaborator of Rubens who also worked in the manner of "Velvet" Brueghel.

VELDE, Esaias van de
Esaias van de Velde (ca. 1590-1630) was a Dutch painter of landscapes and sporting scenes.

VELDE, Jan van de
Jan van de Velde (1593-1641) was a Dutch landscape and animal painter who was better known as an etcher and engraver.

VELDE, Willem van de, the Younger
Willem van de Velde the Younger (1633-1707) was a Dutch painter who specialized in boat and warship subjects. He was the son of the marine painter, Willem van de Velde the Elder.

WEYDEN, Rogier van der

Rogier van der Weyden (1399/1400-1464), a Flemish painter, sculptor and engraver, influenced even more artists than the van Eycks and succeeded them in importance.

WINGHE, Jodocus van de

Jodocus van de Winghe (1544-1603) was a Flemish painter who studied in Italy and specialized in historical scenes and genre subjects.

Bibliography

GENERAL

Berger, K. *Franzoesische Meisterzeichnungen des Neunzehnten Jahrhunderts,* Basel, 1949.

Bernt, W. *Die niederlaendischen Zeichner des 17. Jahrhunderts,* Munich, 1957-58.

Delen, A. J. J. *Flemish Master Drawings of the Seventeenth Century,* New York, 1950.

Gelder, J. G. van. *Dutch Drawings and Prints,* New York, 1959.

Leclerc, A. *Flemish Drawings, XV-XVI Centuries,* New York, 1949.

Lugt, F. *Inventaire général des Dessins des écoles du nord au Musée du Louvre: Ecole Flamande,* 2 vols., Paris, 1949.

Panofsky, E. *Early Netherlandish Painting,* Cambridge, Mass., 1953.

Regteren-Altena, J. Q. van. *Hollaendische Meisterzeichnungen,* Basel, 1948.

Regteren-Altena, J. Q. van. *Dutch Master Drawings of the Seventeenth Century,* New York, 1949.

Schmidt, Degener, F. *Dessins Hollandais de Jérôme Bosch à Rembrandt,* Brussels, 1937-38.

Winkler, F. *Vlaemische Zeichnungen,* Berlin, 1948.

BOSCH

de Tolnay, C. *Hieronymous Bosch,* Basel, 1937.

Baldass, L. *Jheronimus Bosch,* Vienna and Munich, 1959.

BLOEMAERT

Delbanco, G. *Der Maler Abraham Bloemaert,* Strassburg, 1928.

BOUTS

Boon, K. G. *Dieric Bouts,* Brussels, 1957.

Schone, W. *Dieric Bouts und seine Schule,* Berlin, 1938.

BROUWER

Boucher, L. J. C. *Adriaen Brouwer, The Master and His Work,* The Hague, 1962.

BRUEGEL

Bastelaer, R. van, and Loo, G. Hulin de. *Peter Bruegel l'Ancien, son oeuvre et son temps,* Brussels, 1907.

Stridbeck, C. G. *Bruegel Studien,* Stockholm, 1956.

de Tolnay, C. *Die Zeichnungen Pieter Bruegels,* Zurich, 1952.

BUYTEWECH

Begemann, E. Haverkamp. *Willem Buytewech,* Amsterdam, 1959.

Gerard DAVID

Boon, K. G. *Gerard David,* Amsterdam, 1942 (?).

van DYCK

d'Hulst, R. A., and Vey, H. *Antoon van Dyck,* Antwerp and Rotterdam, 1960.

Vey, H. *Van Dyck-Studien,* Cologne, 1955.

van EYCK

Baldass, L. Jan van Eyck. London and New York, 1952.

de GHEYN

Regteren-Altena, J. Q. van. *The Drawings of Jacques de Gheyn,* Amsterdam, 1935.

van der GOES

Rey, R. *Hugo van der Goes,* Brussels, 1945.

GOLTZIUS

Reznicek, E. K. J. *Hendrik Goltzius Zeichnungen,* 2 vols., Utrecht, 1961.

HUYSUM

Grant, M. H. *Jan van Huysum,* Leigh-on-Sea, 1954.

JORDAENS

Delen, A. J. *Jacob Jordaens,* Antwerp, 1943.

d'Hulst, R. A. *De Tekeningen van Jakob Jordaens,* Brussels, 1956.

KONINCK

Gerson, H. *Philips Koninck,* Berlin, 1936.

van LAER (Bamboccio)

Briganti, G. (ed.) *I bamboccianti; pittori della vita popolare nel seicento,* Rome, 1950.

van LEYDEN

Beets, N. *Lucas de Leyde,* Brussels, 1913.

LIEVENS

Schneider, H. *Jan Lievens,* Haarlem, 1932.

MEMLING

Baldass, L. *Hans Memling,* Vienna, 1942.

Bazin, G. *Memling,* New York and Paris, 1939.

OSTADE

Godefroy, L. *L'Oeuvre gravé de Adriaen van Ostade,* Paris, 1930.

Trautscholdt, E. *Ueber Adriaen van Ostade als Zeichner,* Berlin, 1960.

REMBRANDT

Benesch, O. *Rembrandt, Selected Drawings,* London and New York, 1947.

Benesch, O. *The Drawings of Rembrandt,* 6 vols., London, 1954.

RUBENS

Burchard, L. *Loan Exhibition of Works by Peter Paul Rubens, Kt.,* London, 1950.

Burchard, L., and d'Hulst, R. A. *Tekeningen van P. P. Rubens,* Antwerp, 1956.

Held, J. S. *Rubens, Selected Drawings,* London, 1950.

SAENREDAM

Swillens, P. T. A. *Pieter Janszoon Saenredam, Schilder van Haarlem,* Amsterdam, 1935.

Gerard TERBORCH the Younger

Gudlaugsson, S. J. *Gerard ter Borch, the Younger,* 2 vols., The Hague, 1959-60.

Jan van de VELDE

Gelder, J. G. van. *Jan van de Velde, 1593-1641, teekenaar-schilder,* The Hague, 1933.

TERBRUGGHEN

Nicolson, B. *Hendrick Terbrugghen,* London, 1958.